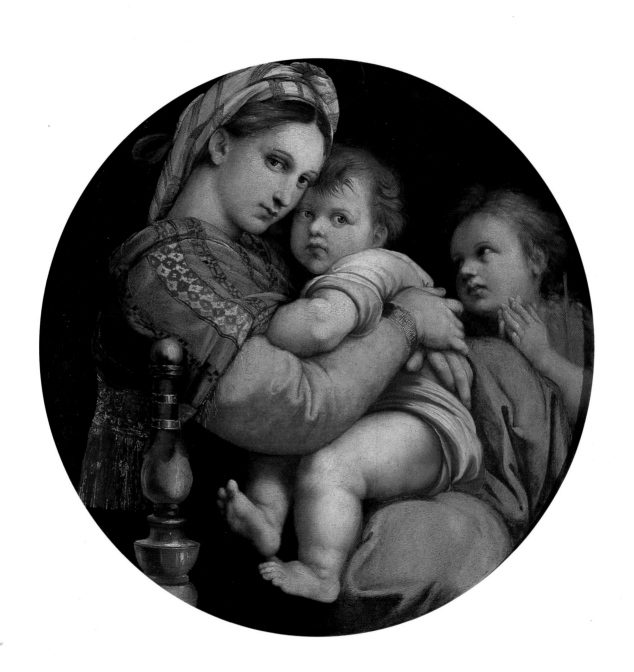

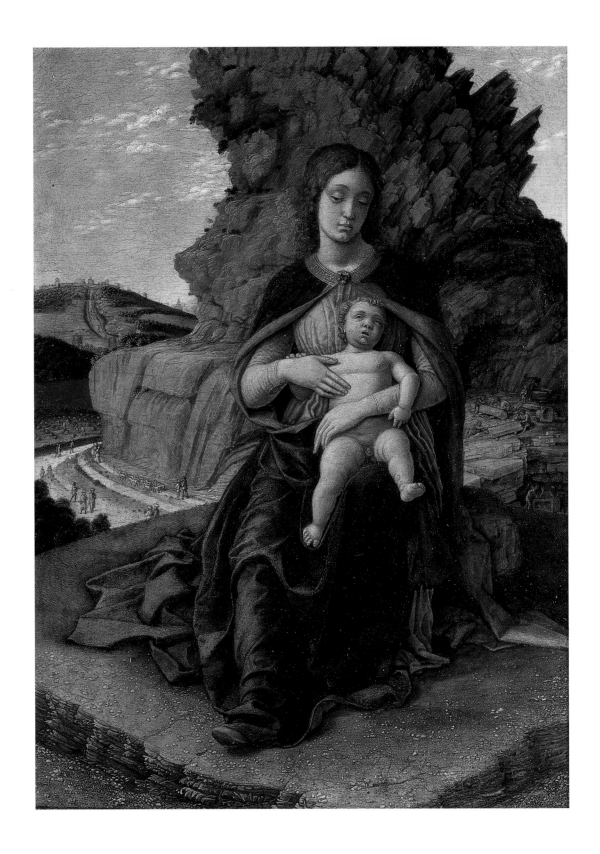

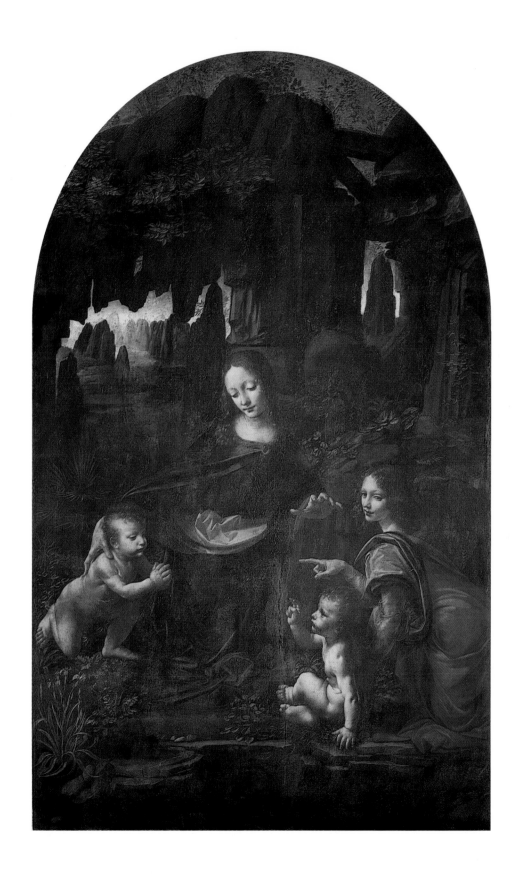

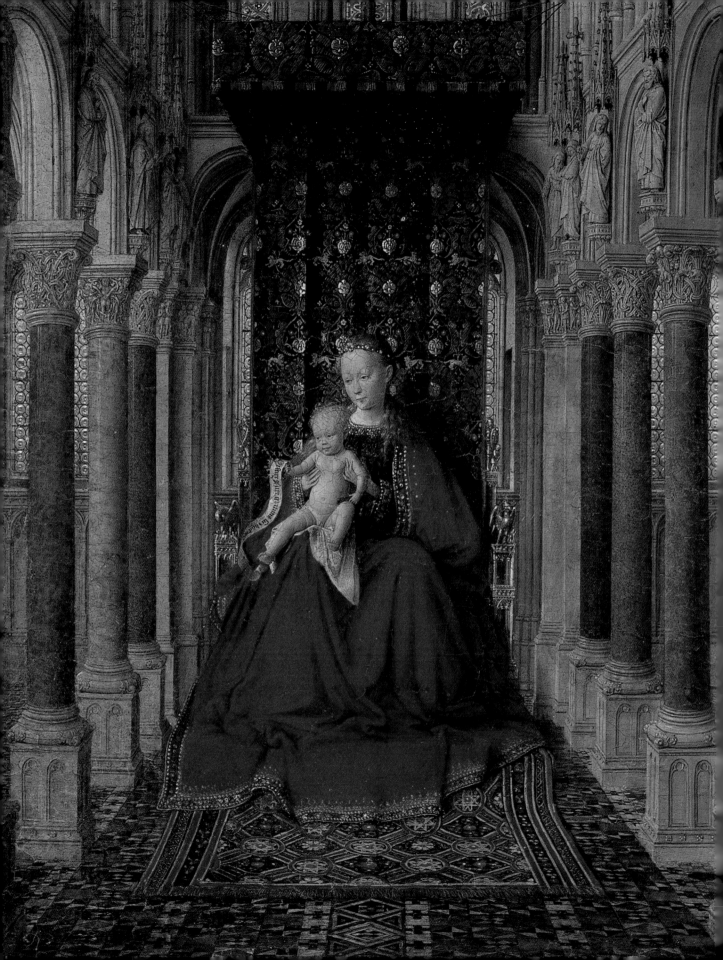

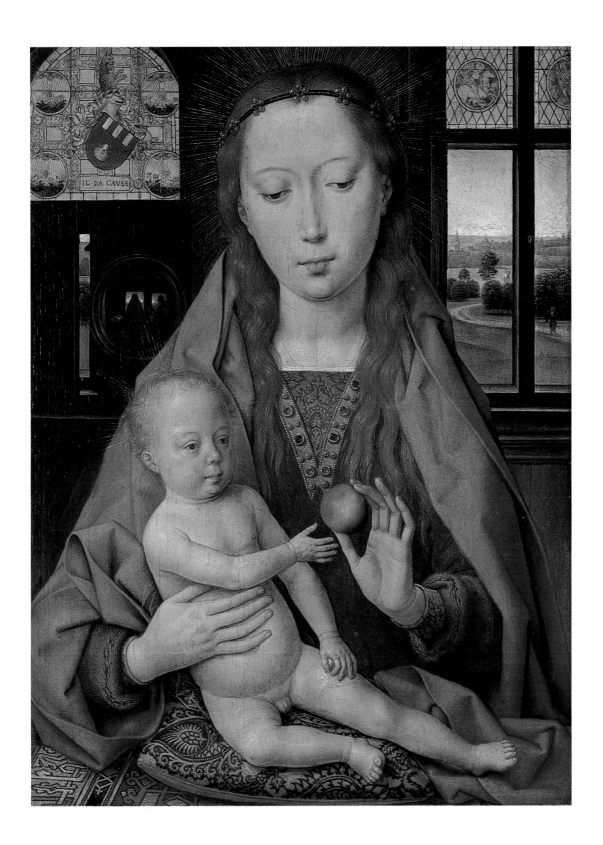

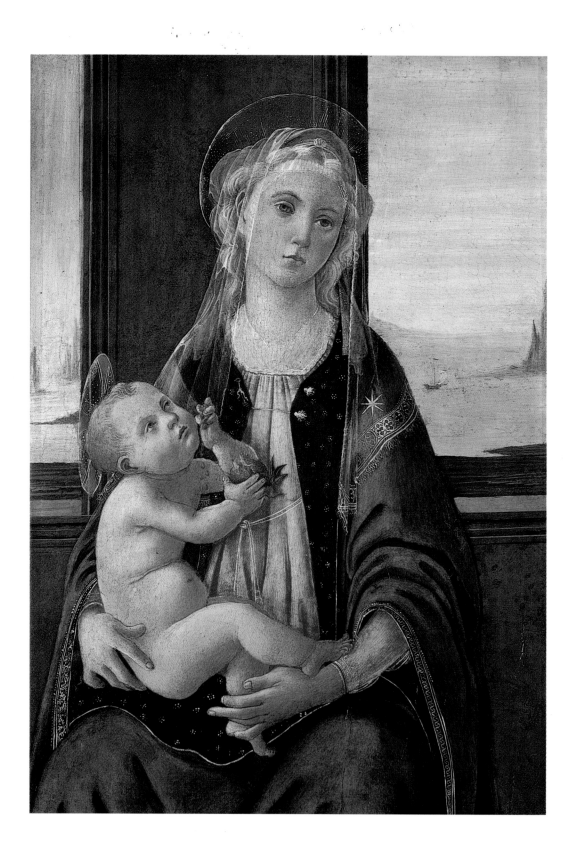

MEDITATIONS
ON MARY

WITH ESSAYS BY

KATHLEEN
NORRIS

AND EXCERPTS FROM THE
KING JAMES VERSION
OF THE BIBLE

VIKING STUDIO

VIKING STUDIO
Published by the Penguin Group
Penguin Putnam Inc., 375 Hudson Street, New York, New York 10014, U.S.A.
Penguin Books Ltd, 27 Wrights Lane, London W8 5TZ, England
Penguin Books Australia Ltd, Ringwood, Victoria, Australia
Penguin Books Canada Ltd, 10 Alcorn Avenue, Toronto, Ontario, Canada M4V 3B2
Penguin Books (N.Z.) Ltd, 182-190 Wairau Road, Auckland 10, New Zealand

Penguin Books Ltd, Registered Offices: Harmondsworth, Middlesex, England

First published in 1999 by Viking Studio, a member of Penguin Putnam Inc.

10 9 8 7 6 5 4 3 2 1

Grateful acknowledgment is made for permission to reprint the following copy-righted texts: "Virgin Mary, Mother of God," "The Annunciation," "Incarnation," and "Dogma" from Amazing Grace *by Kathleen Norris. Copyright © 1998 by Kathleen Norris. Used by permission of Riverhead Books, a member of Penguin Putnam Inc. "February 2: Candlemas/Presentation of the Lord" and "Oz" from* The Cloister Walk *by Kathleen Norris. Copyright © 1996 by Kathleen Norris. Used by permission of Riverhead Books, a member of Penguin Putnam Inc.*

CIP data available
ISBN 0-670-88820-6

Printed in China
Set in Aldus, with Tranjan and Tagliente
Designed by Jaye Zimet

Preceding pages

RAPHAEL
Madonna of the Chair
GALLERIA PALATINA
PALAZZO PITTI, FLORENCE

ANDREA MANTEGNA
Madonna of the Caves
GALLERIA DEGLI UFFIZI
FLORENCE

LEONARDO DA VINCI
The Virgin of the Rocks
MUSÉE DU LOUVRE
PARIS

JAN VAN EYCK
*Enthronement
of Saint Mary*
STAATLICHE
KUNSTSAMMLUNGEN
ALTE MEISTER, DRESDEN

HANS MEMLING
Virgin and Child FROM
DIPTYCH OF MAARTEN VAN
NIEUWENHOVE
MEMLING MUSEUM
SINT-JANSHOSPITAL,
BRUGES

SANDRO BOTTICELLI
Madonna of the Sea
GALLERIA DELL'
ACCADEMIA, FLORENCE

Opposite

PETER PAUL RUBENS
*Madonna and Child
Encircled by Garland
of Flowers*
ALTE PINAKOTHEK
MUNICH

Following page

GEORGES DE LA TOUR
*The Adoration
of the Shepherds*
MUSÉE DU LOURVE, PARIS

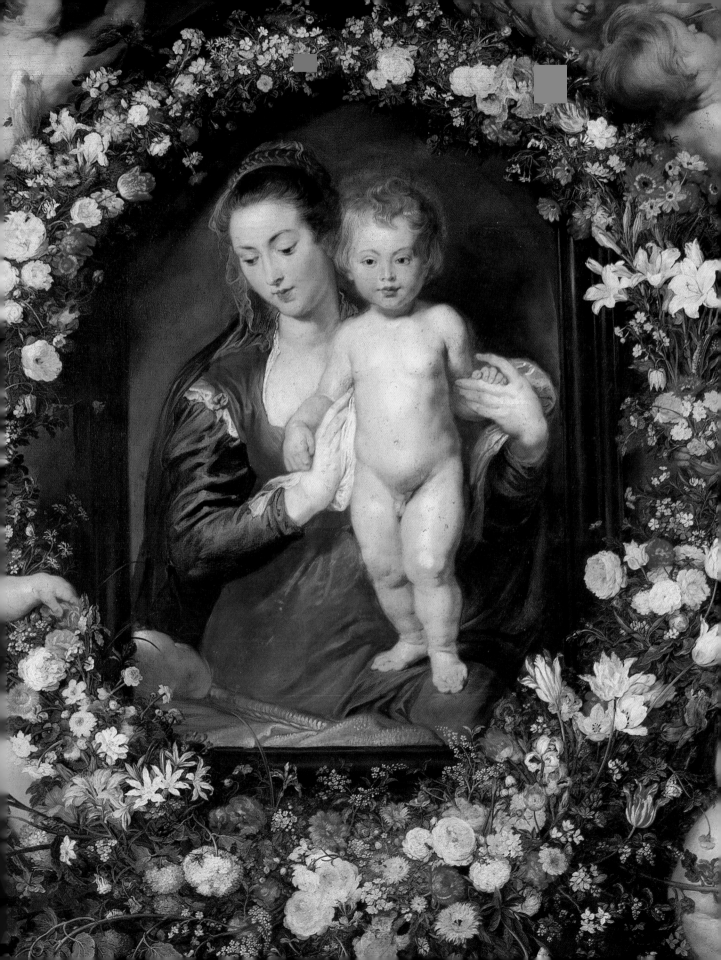

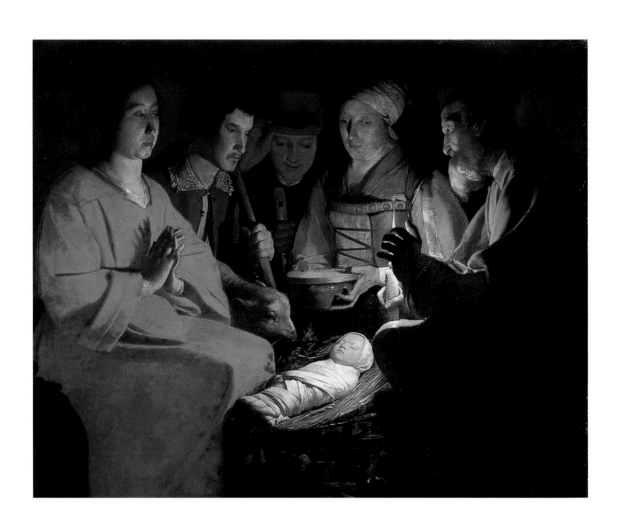

CONTENTS

VIRGIN MARY, MOTHER OF GOD 13

THE ANNUNCIATION 27

INCARNATION 37

CANDLEMAS/PRESENTATION
OF THE LORD 39

DOGMA 43

OZ 51

———

LIFE OF THE VIRGIN 53

INDEX OF ARTISTS III

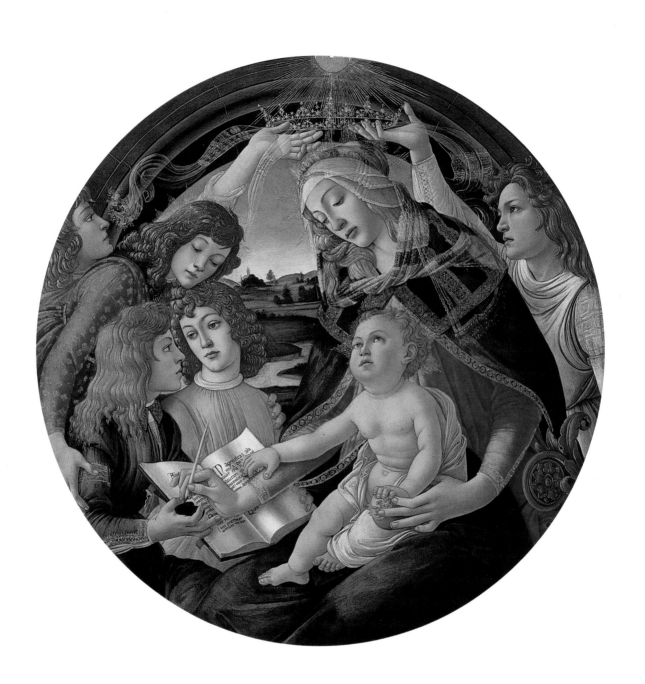

VIRGIN MARY, MOTHER OF GOD

During the 1950s, when I was receiving religious formation in Methodist, Congregational, and in the summer, Presbyterian churches, Mary was more or less invisible to me. Along with the angels of the Nativity, she was one of the decorations my family unpacked every year for Christmas, a strange but welcome seasonal presence who would be relegated to the closet again at the new year. Mary was mysterious, and therefore for Catholics; our religion was more proper, more masculine in ways I had yet to define. As the writer Nancy Mairs has so vividly stated, the Protestantism we both were raised in was one with "all the mystery scrubbed out of it by a vigorous and slightly vinegary reason."

When I first went to a Benedictine abbey fifteen years ago, I wasn't looking for Mary at all. But, over time, as I kept returning to the monks' choir, I found that I was greatly comforted by the presence of Mary in the daily liturgy and also in the church year. I hadn't been to church since high school, and I doubt that I had ever been to a vespers service. So, at first I had no idea where the lovely Magnificat we sang every night was from: "My soul magnifies the Lord, my spirit rejoices in God my savior" (Luke 1:46). When I eventually found it in the first

SANDRO BOTTICELLI
Madonna of the Magnificat
GALLERIA DEGLI UFFIZI
FLORENCE

13

chapter of Luke's Gospel, I was startled but glad to see that it was one pregnant woman's response to a blessing from another. It is the song Mary sings after she has walked to her cousin Elizabeth's village, and on greeting Mary, Elizabeth, who is bearing John the Baptist, recognizes that Mary bears the Messiah.

The song is praise of the God who has blessed two insignificant women in an insignificant region of ancient Judea, and in so doing "has brought down the powerful from their thrones, and lifted up the lowly: [who] has filled the hungry with good things, and sent the rich away empty" (Luke 1:52–53). I later learned that these words echo the song of Hannah in First Samuel, as well as the anguish of the prophets. They are a poetic rendering of a theme that pervades the entire biblical narrative—when God comes into our midst, it is to upset the status quo.

The Magnificat's message is so subversive that for a period during the 1980s the government of Guatemala banned its public recitation (a sanction that I'm sure the monasteries of that country violated daily). But when I came to its words knowing so little about them, I found that all too often they were words I could sing with ease at evening prayer, with a facile (and sometimes sleepy) acceptance. On other nights, however, they were a mother's words, probing uncomfortably into my life. How rich had I been that day, how full of myself? Too full to recognize need and hunger, my own or anyone else's? So powerfully providing for myself that I couldn't admit my need for the help of others? Too busy to know a blessing when it came to me?

It was many months before I took notice of the Madonna and Child in a niche over my shoulder, thoroughly black except for the gold scepter she held in one hand, an un-

Our Lady of Czestochowa
(BLACK MADONNA)
JASNA GORA MONASTERY
CZESTOCHOWA, POLAND

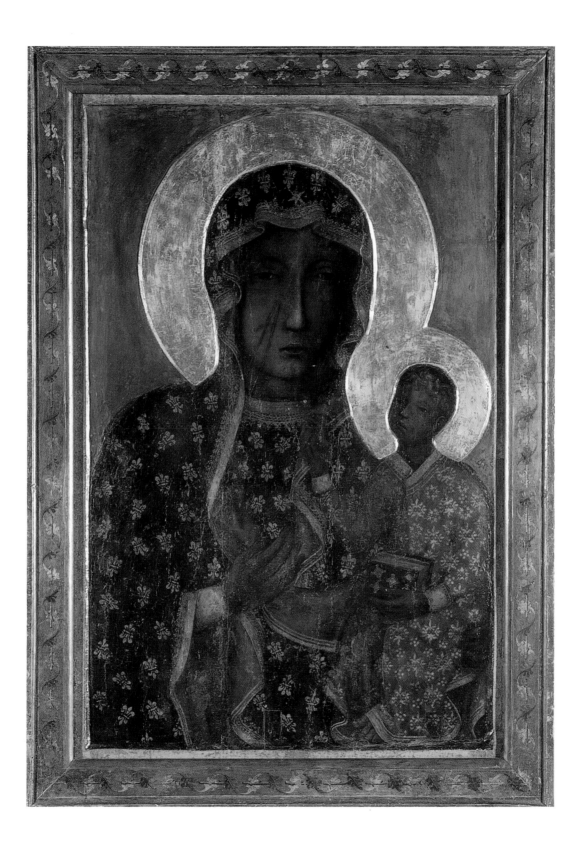

likely presence among mostly white-skinned Benedictine monks in North Dakota, their black habits an almost comical echo of her dress. I came to love her face, its calm strength. And I loved the way she held her child, like any mother, on her outthrust hip. A monk explained that it was the Black Madonna of Einsiedeln, Switzerland, one of many black Madonnas in Europe that have attracted pilgrims for centuries. During the 1980s the Black Madonna of Czestochowa, Poland, became such a potent symbol of resistance to the Communist regime that as many as five million people made an annual pilgrimage to the site. But all of this meant little to me then. I knew only that the statue represented something powerful and that I wanted to be in its presence.

No small part of Mary's emotional weight for many women is the way in which the church has so often used her as an ideal of passive, submissive femininity. But others claim her as a model of strength. I treasure Mary as a biblical interpreter, one who heard and believed what God told her, and who pondered God's promise in her heart, even when, as the Gospel of Luke describes it, it pierced her soul like a sword. This is hardly passivity, but the kind of faith that sustains Christian discipleship. Mary's life is as powerful an evocation of what it can mean to be God's chosen as the life of Moses, or St. Paul. In a recent talk on Mary, Ruth Fox, a Benedictine sister who is president of the Federation of St. Gertrude, a group of women's monasteries, reclaims Mary as a strong peasant woman and asks why, in art and statuary, she is almost always presented "as a teenage beauty queen, forever eighteen years old and . . . perfectly manicured." Depictions of Mary as a wealthy Renaissance woman do far outnumber those that make her look like a woman capable of walking the hill country of Judea and giving birth in a barn, and I believe that Fox

has asked a provocative question, perhaps a prophetic one. I wonder if, as Christians, both Protestant and Catholic, seek to reclaim the Mary of scripture, we may well require more depictions of her as a robust, and even muscular, woman, in both youth and old age.

But I would also caution that if we insist too much on a literal Mary, encasing her too firmly in the dress of a first-century peasant, we risk losing her as a living symbol. Sooner or later a child will inquire, as my ten-year-old niece did recently, after seeing one too many Marys-in-robes, "Why don't people ever show her as a *normal* person?" The "1996 Vergin Mary" that she drew for herself may be alarmingly perky (shades of Barbie!), but her body is strong. She looks as if she might have come from an aerobics workout, ready for anything. Placed on her torso, where Supergirl's "S" might be, is an equally perky dove, representing the Holy Spirit.

As one Benedictine friend of mine pointed out to me, the youthfulness of Mary in Christian art can have a religious significance that far transcends ideological concerns. When I asked him if he had ever seen a depiction of an aging Mary, one with wrinkles, he referred me to several images of the Italian Renaissance, including a crucifixion by Piero della Francesca, and we ended up discussing the Pietà by Michelangelo that is housed in St. Peter's in Rome. That Mary looks much too young to have a thirty-three-year-old son, but in this case the monk believes her depiction to be both aesthetically and theologically right. What he said touched me: "It's an ageless image of Mary because the effects of salvation are already present. A biblical image of this might be Psalm 103's 'your youth is renewed like the eagle's.' She's ageless, but she knows the cost of salvation; she sees it in the death of her son. Her serenity is hard-won, and the wonder of the image is that even when she

is looking straight at death, *holding* it, hers is not a grieving face, but one full of divine love and pity."

Mary's love and pity for her children seems to be what people treasure most about her, and what helps her to serve as a bridge between cultures. One great example of this took place in 1531, when the Virgin Mary appeared to an Indian peasant named Juan Diego on the mountain of Tepayac, in Mexico, leaving behind a cloak, a *tilma*, imprinted with her image. The image has been immortalized as Our Lady of Guadalupe, and Mexican-American theologian Virgilio Elizondo argues, in *The Future Is Mestizo*, that the significance of this image today is that Mary appeared as a "mestiza," or person of mixed race, a symbol of the union of the indigenous Aztec and Spanish invader. What was, and still is, the scandal of miscegenation was given a holy face and name. As a Protestant I'll say it all sounds suspiciously biblical to me, recalling the scandal of the Incarnation itself, the mixing together of human and divine in a young, unmarried woman.

Over the centuries one of Mary's greatest strengths as a symbol is the considerable tension she exemplifies between the humble peasant woman and the powerful mother of God. In a recent essay the writer Rubén Martínez lovingly articulates the paradoxes that enliven his sense of the officially sanctioned Mary of church doctrine, and, to borrow his phrase, the "Undocumented Virgin" of personal experience and legend, folktale, and myth. I should probably take this opportunity to make an aside and state that by "myth" I mean a story that you know must be true the first time you hear it. Or, in the words of a five-year-old child, as related by Gertrude Mueller Nelson in her recent Jungian interpretation of fairy tales and Marian theology, *Here All Dwell Free*, a myth is a story that isn't true on the outside, only on the inside. Human beings, it

Piero della Francesca
Crucifixion, from the
Polyptych of the
Misericordia
Pinacoteca Communale
Sansepolcro

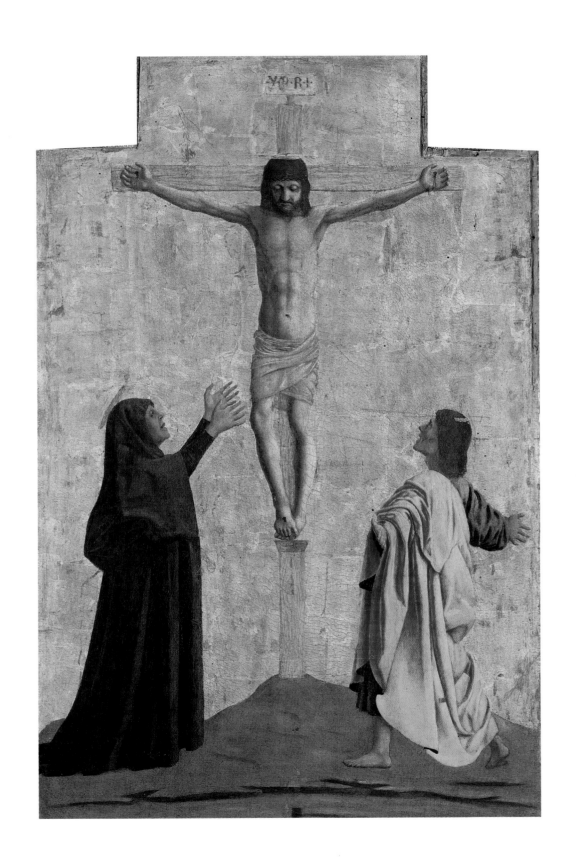

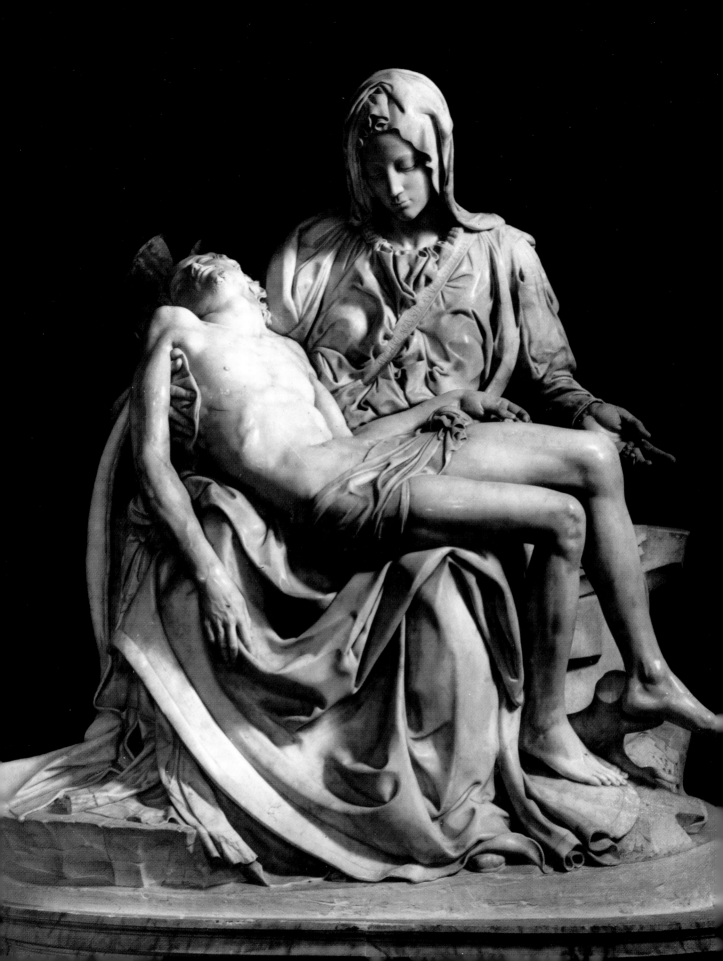

seems to me, require myth as one of the basic necessities of life. Once we have our air and water and a bit of food, we turn to metaphor and to myth-making.

Ana Castillo's recent anthology, *Goddess of the Americas: Writings on the Virgin of Guadalupe*, has convinced me that Mary is often a catalyst for boundary-breaking experiences, contradiction, and paradox, which may suit her to postmodernism. The book includes commentary by pagan, Jewish, and Christian writers who are bold in revealing and reveling in the implications of the Guadalupe myth. The story of Guadalupe, which has come to provide a deep sense of ethnic pride for Mexican-Americans—I once saw a plumber's van in Denver sporting her image on its side—also provides dramatic evidence that it is risky to try to contain a Marian symbol within the confines of either official church doctrine or the narrow mindset of ideological interpretation.

Richard Rodriguez concludes his essay in the anthology by describing his attempts to convey the prophetic power of Guadalupe to a skeptical feminist who can see in this image of a barefoot and pregnant Mary nothing but imperialist oppression and the subjugation of women. You don't understand, Rodriguez says, that the joke is on the living. What joke? the woman responds, and Rodriguez explains:

> The joke is that Spain arrived with missionary zeal at the shores of contemplation. But Spain had no idea of the absorbent strength of Indian spirituality. By the waters of baptism, the active European was entirely absorbed within the contemplation of the Indian. The faith that Europe imposed in the sixteenth century was, by virtue of the Guadalupe, embraced by the Indian. Catholicism has become an Indian religion. By the twenty-first century, the locus of the Catholic church, by virtue of numbers, will be Latin America,

MICHELANGELO
BUONARROTI
La Pietà
BASILICA OF ST. PETER
ROME

Once Marian imagery has truly been absorbed by a
church or a culture, things are never simple. Or they are en-
tirely so. Who is this Mary? For one Benedictine sister the bib-
lical Mary exemplifies an intimate relationship to God, based
on listening and responding to God's word, that "calls all
Christians to the deep, personal, and daily love of Jesus
Christ." As for myself, I have come to think of Mary as the pa-
tron saint of "both/and" passion over "either/or" reasoning,
and as such, she delights my poetic soul. Ever since I first en-
countered Mary in that Benedictine abbey I have learned never
to discount her ability to confront and disarm the polarities
that so often bring human endeavors to impasse: the subjective
and objective, the expansive and the parochial, the affective and
the intellectual.

I used to feel the dissonance whenever I heard Mary
described as both Virgin and Mother; she seemed to set an im-
possible standard for any woman. But this was narrow-minded
on my part. What Mary does is to show me how I indeed can
be *both* virgin *and* mother. Virgin to the extent that I remain
"one-in-myself," able to come to things with newness of heart;
mother to the extent that I forget myself in the nurture and
service of others, embracing the ripeness of maturity that this
requires. This Mary is a gender-bender; she could do the same
for any man.

I owe my reconciliation of the Virgin and the Mother
to the Black Madonna. Late one night at the abbey I sat before
her statue, not consciously praying, but simply tired. Suddenly
words welled up from deep inside me, words I did not intend to
say—*I want to know motherhood.* Stunned by my boldness,

and the impossibility of the request—I have known since adolescence that motherhood was beyond my capacities—I began to weep. This remains my only experience of prayer as defined by St. Anthony of the Desert; he called a true prayer one you don't understand. When, a few months later, through an improbable set of circumstances, I found myself caring for a seventeen-month-old niece with a bad case of the chicken pox, I was amazed to realize that my prayer was being answered in a most concrete, exhausting, and rewarding way. I also sensed that the prayer would continue to be answered in many other ways throughout my life.

It is difficult to feel, in the western Dakotas, that one is on the cutting edge of any cultural phenomenon. The stiff breeze of the zeitgeist usually passes us by, barely ruffling the tightly permed and sprayed "bubble cut" hairdos that have been popular with women here since the 1950s. So I was startled to find that so many other Protestants, including many clergy, were drawn to monasteries in the 1980s, and that we became better acquainted with Mary in the process. And I was surprised to find that others had been pondering the Black Madonna. In her book *Longing for Darkness*, China Galland relates that when she found herself alienated from her Catholic faith, it was the loss of the ability to venerate the Virgin Mary that hurt the most. She went far afield in seeking other female images of the holy—to Buddhism (the goddess Tara) and Hinduism (Kali)—and they led her back to Mary. It is in the Benedictine abbey at Einsiedeln, standing before the Black Madonna as the monks sang the "Salve Regina," that Galland first senses "a way back to what had been lost."

I'm a garden-variety Christian, if an eccentric one; Galland seems a remarkably eclectic Buddhist. We both encountered the Black Madonna, and she changed us. We could do

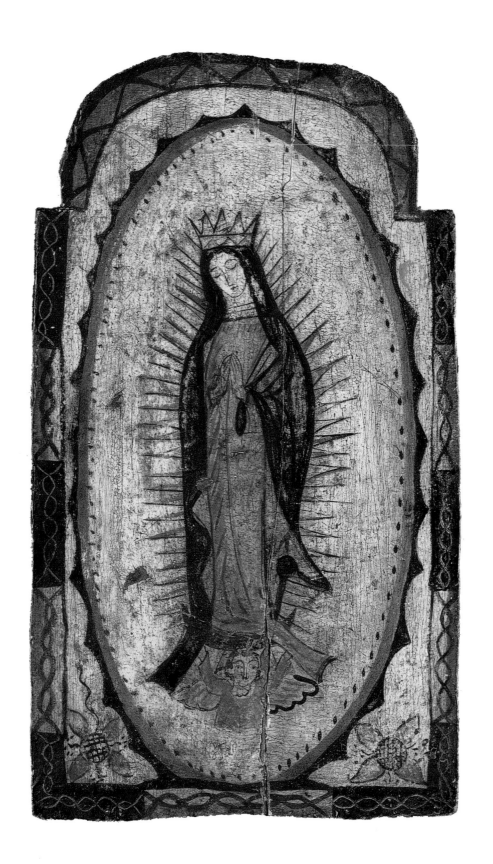

worse than to stick with her, this Mary, who, as the affable parish priest in my small town has said to me, has her ways of going in, under, around, and through any box we try to put her in. We can sympathize with the Nicaraguan tailor in the village of Cuapa, who, when the Virgin began appearing to him in 1980, prayed that she would choose someone else, as he had problems enough!

There's a lot of *room* in Mary. A seminary professor, a Presbyterian, employs the language of the early church in telling a student struggling with family problems, "You can always go to Theotokos [Greek for 'God-bearer'], because she understands suffering." A grieving Lutheran woman in South Dakota tells me, "I love Mary, because she also knew what it is to lose a child." And an elderly Parsee woman in India proudly shows a visiting Benedictine nun her little shrine to Mary, saying, "I'm not a Christian, but I love *her*."

25

PEDRO ANTONIO FRESQUIS
Our Lady of Guadalupe
NATIONAL MUSEUM OF
AMERICAN ART,
WASHINGTON, D.C.

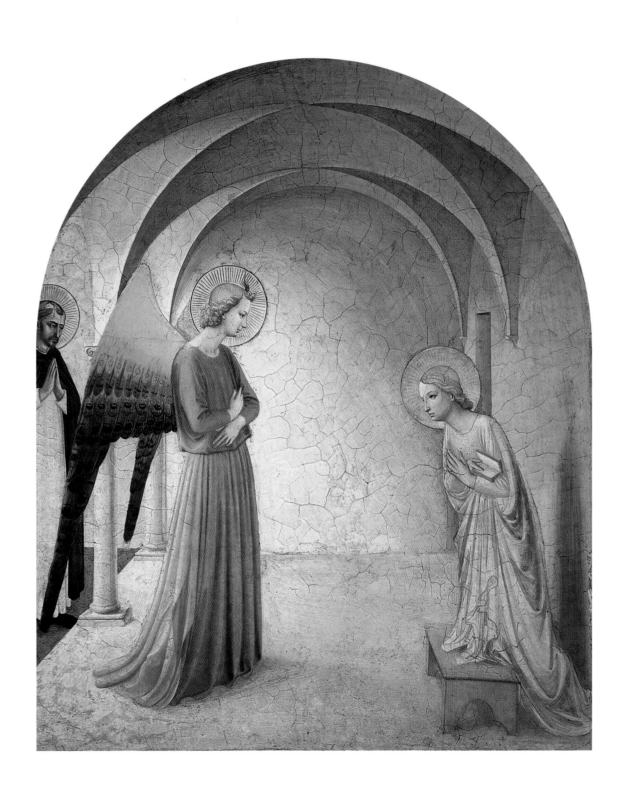

THE ANNUNCIATION

My only rule: If I understand
something, it's no mystery.

—SCOTT CAIRNS,
"THE TRANSLATION OF RAIMUNDO LUZ: MY GOOD LUCK"

If God's incomprehensibility does not grip us in a word,
if it does not draw us into his superluminous darkness,
if it does not call us out of the little house of our homely,
close-hugged truths . . . we have misunderstood
the words of Christianity.

—KARL RAHNER, POETRY AND THE CHRISTIAN

A nnunciation" means "the announcement." It would not be a scary word at all, except that as one of the Christian mysteries, it is part of a language of story, poetry, image, and symbol that the Christian tradition has employed for centuries to convey the central tenets of the faith. The Annunciation, Incarnation, Transfiguration, Resurrection. A Dominican friend defines the mysteries simply as "events in the life of Christ celebrated as stories in the gospels, and meant to be lived by believers." But modern believers tend to trust in therapy more than in mystery, a fact that tends to manifest itself in worship that employs the bland speech of pop psychology and self-help rather than

FRA ANGELICO
The Annunciation
SAN MARCO, FLORENCE

language resonant with poetic meaning—for example, a call to worship that begins: "Use this hour, Lord, to get our perspectives straight again." Rather than express awe, let alone those negative feelings, fear and trembling, as we come into the presence of God, crying "Holy, Holy, Holy," we focus totally on ourselves, and arrogantly issue an imperative to God. Use this hour, because we're busy later; just send us a bill, as any therapist would, and we'll zip off a check in the mail. But the mystery of worship, which is God's presence and our response to it, does not work that way.

The profound skepticism of our age, the mistrust of all that has been handed to us by our grandfathers and grandmothers as tradition, has led to a curious failure of the imagination, manifested in language that is thoroughly comfortable, and satisfyingly unchallenging. A hymn whose name I have forgotten cheerfully asks God to "make our goals your own." A so-called prayer of confession confesses nothing but whines to God "that we have hindered your will and way for us by keeping portions of our lives apart from your influence." To my ear, such language reflects an idolatry of ourselves, that is, the notion that the measure of what we can understand, what is readily comprehensible and acceptable to us, is also the measure of God. It leads all too many clerics to simply trounce on mystery and in the process say remarkably foolish things. The Annunciation is as good as any a place to start.

I once heard a Protestant clergywoman say to an ecumenical assembly, "We all know there was no Virgin Birth. Mary was just an unwed, pregnant teenager, and God told her it was okay. That's the message we need to give girls today, that God loves them, and forget all this nonsense about a Virgin Birth." A gasp went up; people shook their heads. This was the first (and only) gratuitously offensive remark made at a con-

DANTE GABRIEL ROSSETTI
Ecce Ancilla Domini
TATE GALLERY, LONDON

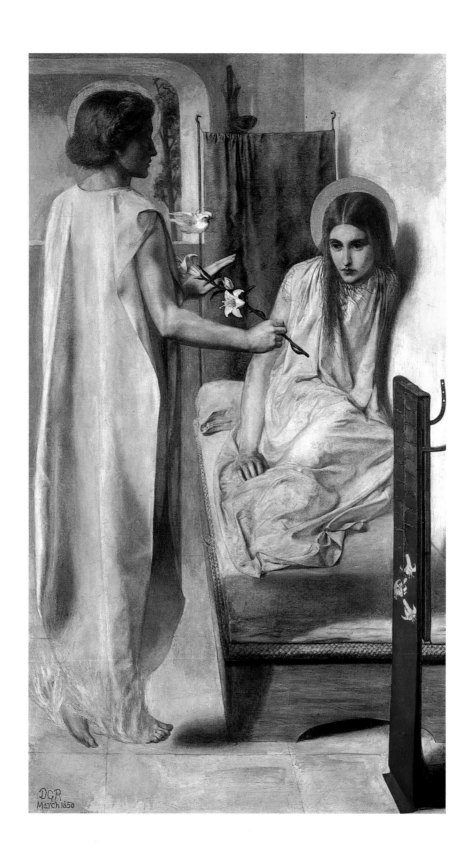

vention marked by great theological diversity. When it came, I happened to be sitting between some Russian Orthodox, who were offended theologically, and black Baptists, whose sense of theological affront was mixed with social concern. They were not at all pleased to hear a well-educated, middle-class white woman say that what we need to tell pregnant teenagers is, "It's okay."

I realized that my own anger at the woman's arrogance had deep personal roots. I was taken back to my teenage years, when the "demythologizing" of Christianity that I had encountered in a misguided study of modern theology had led me to conclude that there was little in the religion for me. In the classroom, at least, it seemed that anything in the Bible that didn't stand up to reason, that we couldn't explain, was primitive, infantile, ripe for discarding. So I took all my longing for the sacred, for mystery, into the realm of poetry, and found a place for myself there. Now, more than thirty years later, I sat in a room full of Christians and thought, *My God, they're still at it, still trying to leach every bit of mystery out of this religion, still substituting the most trite language imaginable. You're okay, the boy you screwed when you were both too drunk to stand is okay, all God chooses to say about it is, it's okay.*

The job of any preacher, it seems to me, is not to dismiss the Annunciation because it doesn't appeal to modern prejudices but to remind congregations of why it might still be an important story. I once heard a Benedictine friend who is an Assiniboine Indian preach on the Annunciation to an Indian congregation. "The first thing Gabriel does when he encounters Mary," he said, "is to give her a new name: 'Most favored one.' It's a naming ceremony," he emphasized, making a connection that excited and delighted his listeners. When I brood

on the story of the Annunciation, I like to think about what it means to be "overshadowed" by the Holy Spirit; I wonder if a kind of overshadowing isn't what every young woman pregnant for the first time might feel, caught up in something so much larger than herself. I think of James Wright's little poem "Trouble," and the wonder of his pregnant mill-town girl. The butt of jokes, the taunt of gossips, she is amazed to carry such power within herself. "Sixteen years, and / all that time, she thought she was nothing / but skin and bones." Wright's poem does, it seems to me, what the clergywoman talks about doing, but without resorting to ideology or the false assurance that "it's okay." Told all her life that she is "nothing," the girl discovers in herself another, deeper reality. A mystery; something holy, with a potential for salvation. The poem has challenged me for years to wonder what such a radically new sense of oneself would entail. Could it be a form of virgin birth?

Wondering at the many things that the story of the Annunciation might mean, I take refuge in the fact that for centuries so many poets and painters have found it worthy of consideration. European art would not have been enriched had Fra Angelico, or Dante Gabriel Rossetti for that matter, simply realized that the Annunciation was a form of negative thinking, moralistic nonsense that only a modern mindset—resolutely intellectual, professional, therapeutic—could have straightened out for them. I am glad also that many artists and poets are still willing to explore the metaphor (and by that I mean the truth) of the Virgin Birth. The contemporary poet Laurie Sheck, in her poem "The Annunciation," respects the "honest grace" that Mary shows by not attempting to hide her fear in the presence of the angel, her fear of the changes within her body. I suspect that Mary's "yes" to her new identity, to the immense and wondrous possibilities of her new and holy

31

name, may provide an excellent means of conveying to girls that there is something in them that no man can touch; that belongs only to them, and to God.

When I hear remarks like the one made by the pastor at that conference, I am struck mainly by how narrow and impoverished a concept of virginity it reveals. It's in the monastic world that I find a broader and also more relevant grasp of what it could mean to be virgin. Thomas Merton, in *Conjectures of a Guilty Bystander*, describes the true identity that he seeks in contemplative prayer as a "point vierge" at the center of his being, "a point untouched by illusion, a point of pure truth . . . which belongs entirely to God, which is inaccessible to the fantasies of our own mind or the brutalities of our own will. This little point . . . of absolute poverty," he wrote, "is the pure glory of God in us."

It is only when we stop idolizing the illusion of our control over the events of life and recognize our poverty that we become virgin in the sense that Merton means. Adolescents tend to be better at this than grown-ups, because they are continually told that they don't know enough, and they lack the means to hide behind professional credentials. The whole world confirms to them that they are indeed poor, regrettably laboring through what is called "the awkward age." It is no wonder that teenagers like to run in packs, that they surround themselves with people as gawky and unformed as themselves. But it is in adolescence that the fully formed adult self begins to emerge, and if a person has been fortunate, allowed to develop at his or her own pace, this self is a liberating force, and it is virgin. That is, it is one-in-itself, better able to cope with peer pressure, as it can more readily measure what is true to one's self, and what would violate it. Even adolescent self-absorption recedes as one's capacity for the mystery of hospitality grows:

EL GRECO
The Annunciation
MUSEUM OF FINE ARTS
BUDAPEST

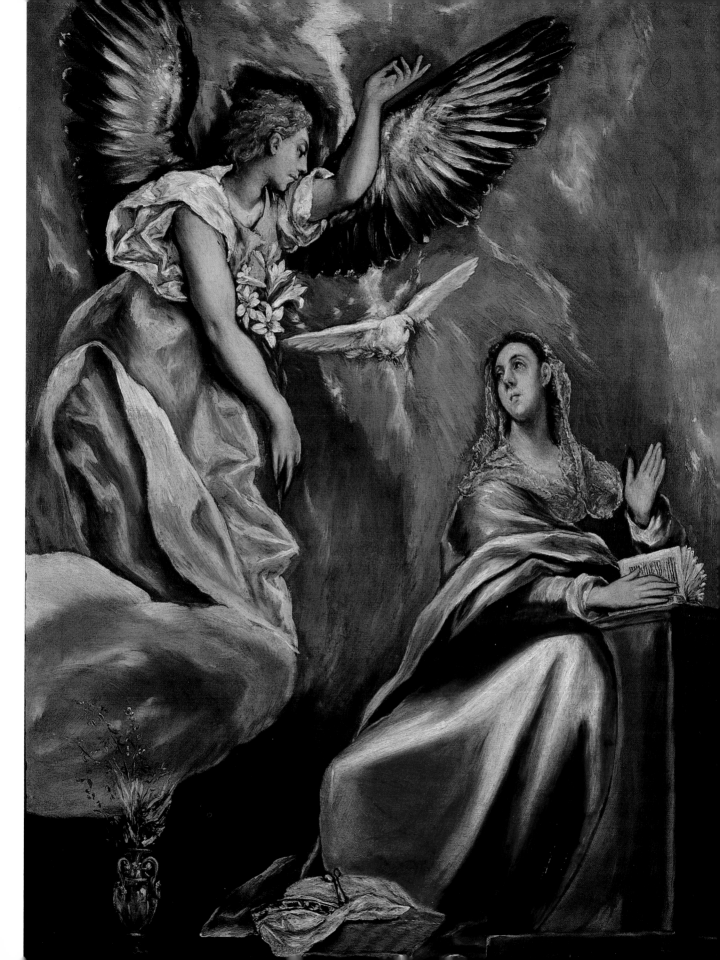

it is only as one is at home in oneself that one may be truly hospitable to others—welcoming, but not overbearing, affably pliant but not subject to crass manipulation. This difficult balance is maintained only as one remains virgin, cognizant of oneself as valuable, unique, and undiminishable at core.

What may trouble modern people most about this concept of virginity, and the story of the Annunciation itself, is what I find most inspiring; there's no room in the story for the catch-22 of sexual liberation. It was not uncommon, in the 1960s, for young men to insist that their girlfriends seek medical treatment for "frigidity" if they resisted sexual intimacy. In many cases the young women were reasoning in a mature fashion, doubting that they were ready for sex, at fourteen or seventeen years of age, and wondering if their boyfriends were as ready as they pretended to be. In doing so, they were regarding sexual intercourse as a major rite of passage, one that would foster but also require a deepening maturity and emotional commitment, and they had the good sense to wonder if it might not be a good idea to become more their own person before sharing themselves so intimately with another. The remedy for this pathology? Birth control pills, of course. These girls were not well served by doctors, or well-meaning clergy who told them not to worry, it's okay.

We all need to be told that God loves us, and the mystery of the Annunciation reveals an aspect of that love. But it also suggests that our response to love is critical. A few verses before the angel appears to Mary in the first chapter of Luke's Gospel, another annunciation occurs; an angel announces to an old man, Zechariah, that his equally aged wife is to bear a son who will "make ready a people prepared for the Lord." The couple are to name him John; he is known to us as John the Baptist. Zechariah says to the angel, "How will I know that this

is so?" which is a radically different response from the one Mary makes. She says, "How can this be?"

I interpret this to mean that while Zechariah is seeking knowledge and information, Mary contents herself with wisdom, with pondering a state of being. God's response to Zechariah is to strike him dumb during the entire term of this son's gestation, giving him a pregnancy of his own. He does not speak again until after the child is born, and he has written on a tablet what the angel has said to him: "His name is John." This confounds his relatives, who had expected that the child would be named after his father. I read Zechariah's punishment as a grace, in that he could not say anything to further compound his initial arrogance when confronted with mystery. When he does speak again, it is to praise God; he's had nine months to think it over.

Mary's "How can this be?" is a simpler response than Zechariah's, and also more profound. She does not lose her voice but finds it. Like any of the prophets, she asserts herself before God, saying, "Here am I." There is no arrogance, however, but only holy fear and wonder. Mary proceeds—as we must do in life—making her commitment without knowing much about what it will entail or where it will lead. I treasure the story because it forces me to ask: When the mystery of God's love breaks through into my consciousness, do I run from it? Do I ask of it what it cannot answer? Shrugging, do I retreat into facile clichés, the popular but false wisdom of what "we all know"? Or am I virgin enough to respond from my deepest, truest self, and say something new, a "yes" that will change me forever?

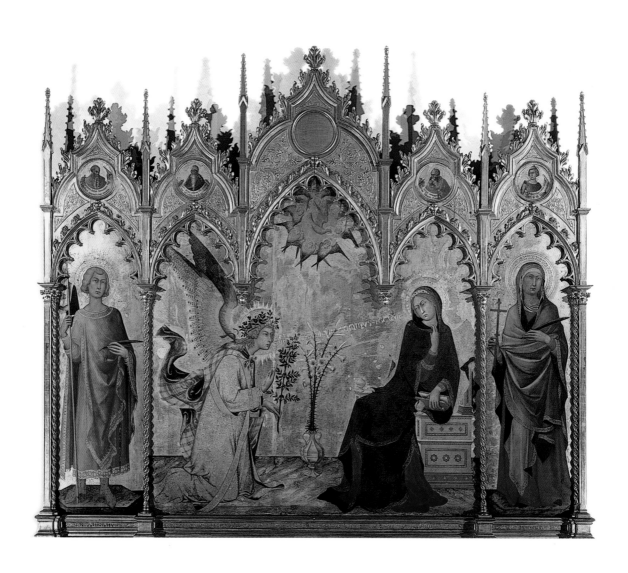

INCARNATION

or me, the Incarnation is the place, if you will, where hope contends with fear. Not an antique doctrine at all, but reality—as ordinary as my everyday struggles with fears great and small, as exalted as the hope that allows me some measure of peace when I soldier on in the daily round.

I also tend to think of the Incarnation in terms of language, as a wonderful tension between the Word of God and human words, which is evident in the language describing the Annunciation. When the angel Gabriel first addresses Mary, it is in the exalted, even imperial, language: "Hail, thou that art highly favoured, the Lord is with thee." (I use the King James Version because the New Revised Standard is flat by comparison, and sounds too much like *Star Wars* talk: "Greetings, favored one. The Lord is with you.")

Gabriel addresses his majestic words in an unlikely setting to an unlikely person, someone poor and powerless, extremely vulnerable in her place and time, a young peasant woman about to find herself pregnant before her wedding. But if the angel's words express the hopes of generations of Israel, Mary's response is silence. The angel spells out the wonders that are about to ensue, again in exalted terms: Mary's son will

SIMONE MARTINI
The Annunciation
GALLERIA DEGLI UFFIZI
FLORENCE

be a king whose kingdom has no end. "How can this be?" Mary exclaims, finally, and the angel says, "The power of the Most High will overshadow you; *therefore* the child will be called Son of God" (emphasis mine). Mary says very little, and she says it simply: "Here I am," and "let it be."

The angel's "therefore" seems alarmingly significant, the seed of what Christian theologians have for well over a thousand years termed the scandal of the Incarnation. It also resonates with my own life. When a place or time seems touched by God, it is an overshadowing, a sudden eclipsing of my priorities and plans. But even in terrible circumstances and calamities, in matters of life and death, if I sense that I am in the shadow of God, I find light, so much light that my vision improves dramatically. I know that holiness is near.

And it is not robed in majesty. It does not assert itself with the raw power of empire (not even the little empire of the self in which I all too often reside), but it waits in puzzlement, it hesitates. Coming from Galilee, as it were, from a place of little hope, it reveals the ordinary circumstances of my life to be full of mystery, and gospel, which means "good news."

FEBRUARY 2:
CANDLEMAS/
PRESENTATION
OF THE LORD

*And Simeon blessed them and said to Mary his mother,
"Behold this child is destined for the fall and rise of many
in Israel, and to be a sign that will be contradicted
(and you yourself a sword will pierce)
so that the thoughts of many hearts will be revealed."*

(LUKE 2:34–35)

*The darkness is still with us, O Lord. You are still hidden and
the world which you have made does not want to know you
or receive you . . . You are still the hidden child in a world
grown old . . . You are still obscured by the veils of this world's
history, you are still destined not to be acknowledged in the
scandal of your death on the cross . . . But I, O hidden Lord of
all things, boldly affirm my faith in you. In confessing you,
I take my stand with you . . . If I make this avowal of faith,
it must pierce the depths of my heart like a sword,
I must bend my knee before you, saying, I must alter my life.
I still have to become a Christian.*

—KARL RAHNER, PRAYERS FOR MEDITATION

Today, the monks are doing something that seems futile, and a bit foolish. They are blessing candles, all the candles they'll use during worship for the coming year. It's good to think of the light hidden inside those new candles; walking to prayer each morning in the bitter cold, I know that the light comes earlier now. I can feel the change, the hours of daylight increasing. The ground has been covered by snow since Thanksgiving; in this climate, I'll seize hold of any bit of hope, even if it's monks saying prayers over candles.

The reading from Karl Rahner, at morning prayer, came as a shock. To hear so esteemed a theologian cry out, "I have still to become a Christian" was humbling. The words have stayed with me all day. I wonder if one of the reasons I love the Benedictines so much is that they seldom make big noises about being Christians. Though they live with the Bible more intimately than most people, they don't thump on it, or with it, the way gorillas thump on their chests to remind anyone within earshot of who they are. Benedictines remind me more of the disciples of Jesus, who are revealed in the gospel accounts as people who were not afraid to admit their doubts, their needs, their lack of faith. "Lord, increase our faith," they say, "Teach us to pray." They kept getting the theology wrong, and Jesus, more or less patiently, kept trying to set them straight. Except for Peter, the disciples were not even certain who Jesus was: "Have I been with you all this time, and still you do not know me?" Jesus asks in the Gospel of John, not long before he's arrested and sentenced to death.

Maybe because it's the heart of winter, and the air is so cold that it hurts to breathe, the image of the sword from Luke's gospel comes to mind as I walk back home after vespers. We've heard it twice today, at morning prayer and at Mass. I

wonder if Mary is the mother of *lectio*, because as she pondered her life and the life of her son, she kept Simeon's hard prophecy in her heart. So much that came easily in the fall has become a struggle this winter. I still walk to morning prayer— it seems necessary to do—but it requires more effort now. Still I know that it is nothing that I do that matters, but what I am, what I will become. Maybe Mary's story, and this feast, tell us that if the scriptures *don't* sometimes pierce us like a sword, we're not paying close enough attention.

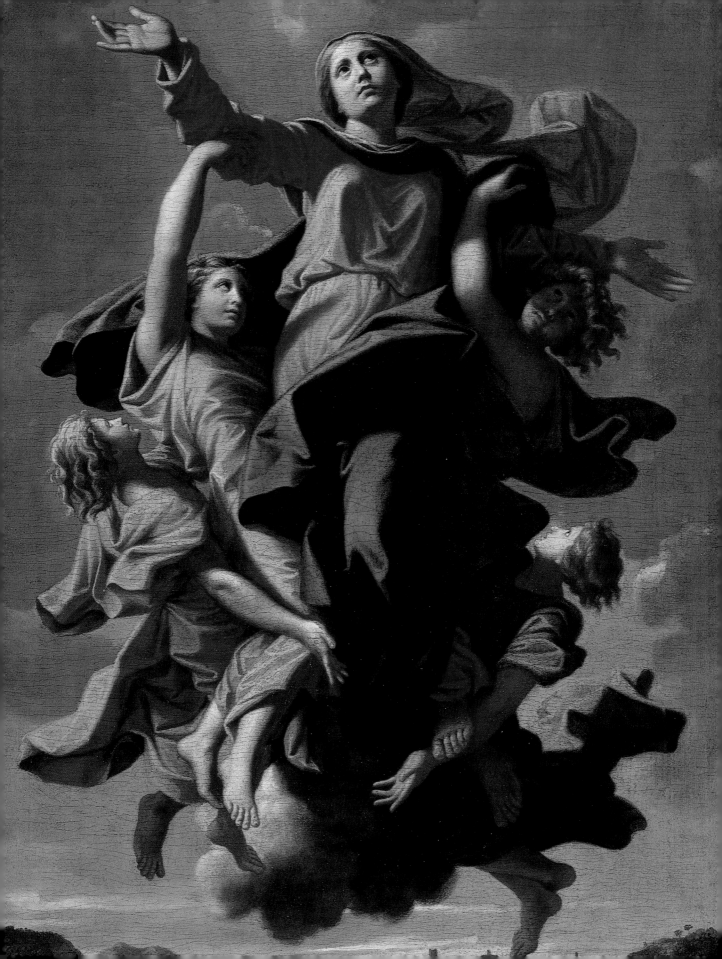

DOGMA

Dogma is an instrument for penetrating reality. Christian dogma is about the only thing left in the world that surely guards and respects mystery.

—FLANNERY O'CONNOR

I am indebted to the writer and sculptor Edward Robinson for pointing out to me that the word "dogmatic" as used today means, ironically, to have abandoned the original spirit of dogma. In the early church, he says, dogma simply meant acceptance, or consensus, what people could agree on. The Greek root from which "dogma" comes means "what seems good, fitting, becoming." Thus, the word "beauty" might be a more fitting synonym for dogma than what has become its synonym in contemporary English: "doctrine," or a teaching.

For Christians, dogmas represent what is basically agreed on as the foundation of faith. They are a restatement of the Christian mysteries, and as such, tend not to be foremost in people's minds when they come to church. Dogmas undergird the faith, and as they constitute the primary content of the creeds, they surface in worship when a creed is read aloud. The most ancient of the creeds that is commonly recited, The Apostles' Creed, begins, "We believe," and proceeds to tell the mystery of Jesus' coming, death, and resurrection remarkably quickly, and in simple language.

NICOLAS POUSSIN
*The Assumption
of the Virgin*
MUSÉE DU LOUVRE, PARIS

Friends who find my religious conversion inexplicable, if not annoying, sometimes ask how it is that I can live with dogma. It's not that difficult, I tell them, because dogma is not dogmatism, which, in the words of Gregory Wolfe, results when "theological systems . . . become calcified and unreal." Dogma in this dogmatic sense is peripheral to my concerns. If I do get caught up in fretting over one of the mysteries of the faith that is expressed as a dogma, it's usually a sign that something else is wrong, something I need to sit with for a while and pray over so that I can see the problem clearly. But when dogma is in its proper place, as beauty, it appeals to my poetic sensibility, rather than to my more linear intelligence. I have a hard time, in fact, separating "dogma" out from the sheer joy of worship. At its best, the sights and sounds of worship, its stories, poems, hymns, and liturgical actions, are beautiful in the sense of "good, fitting, becoming."

One of my guilty pleasures, for example, is the celebration of the dogma of the Assumption of Mary into heaven. Presbyterians are not supposed to even notice the Assumption, and the fact that it has become one of my favorite celebrations of the Christian year has little to do with Pope Pius XII's declaration of the dogma in 1950, and everything to do with my love for the ancient stories, symbols, and metaphors that surround the vigil and the feast. I never had to memorize the Baltimore Catechism on the dogma of the Assumption, and I haven't yet read what the new catechism has to say. I do know that it became a dogma in the best possible way, because from the earliest days of the church ordinary Christians believed and celebrated it, and finally, after nearly two thousand years, the church responded by making it official. Dogma: what seems right.

Every year I listen attentively to whatever extra-biblical texts are being read at the monastic vigil on the

RAPHAEL
Madonna Sistina
GEMÄLDEGALERIE
ALTE MEISTER, DRESDEN

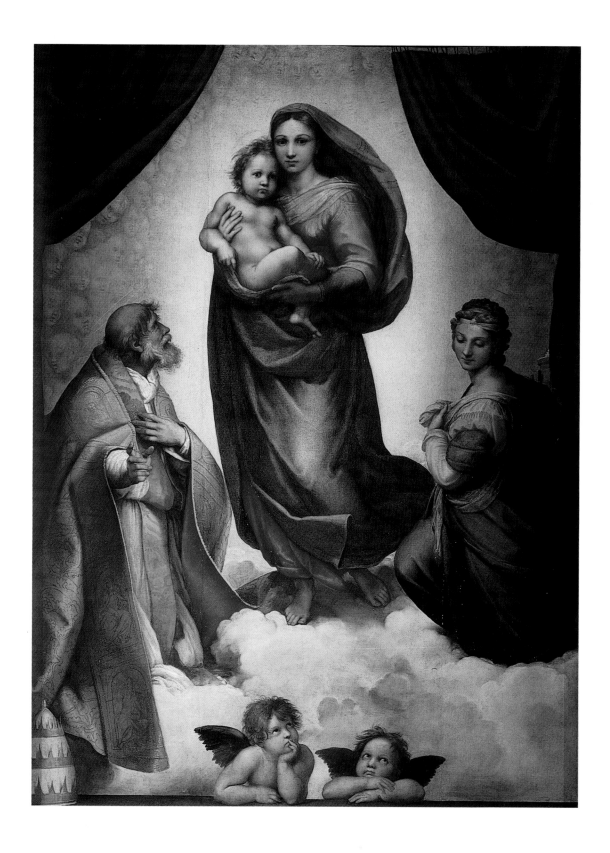

evening before the celebration. Monastic communities choose these readings carefully from the mystical or scholarly Christian tradition, and I may hear anything from John of Damascus or Gregory of Tours to Karl Rahner, the documents of Vatican II, or Pope John Paul II. One of my favorite texts comes from Julian of Norwich, who recounts how Christ had asked her, repeatedly, "Do you want to see her?" He then gives Julian visions of Mary in three guises, as a pregnant young woman, a mother grieving under the cross, and, Julian reports, "as she is now, delightful, glorious, and rejoicing." I find the lectionary readings at Mass similarly enticing, and the gospel account in Luke of Mary and Elizabeth, both heavily pregnant, greeting and blessing one another, is a scene replete with gladness.

Women have told me that pregnancy, while a powerful expression of the body's mystery, is also a humbling reminder of one's dependence on the physical. All of it finds expression in the prayer Mary makes in response to Elizabeth's blessing, the Magnificat that has been part of daily Christian liturgy for many centuries. In this great poem, I wonder if it isn't the upheaval in Mary's own body that triggers her prophetic understanding of how God acts in the world: "He has brought down the powerful from their thrones, and lifted up the lowly; he has filled the hungry with good things, and sent the rich away empty" (Luke 1:52).

I also love to hear, and to ponder, the passage from Revelation that is read every year on the Assumption: "A great portent appeared in heaven: a woman clothed with the sun, the moon beneath her feet, and on her head a crown of twelve stars. She was pregnant and was crying out in birthpangs, in the agony of giving birth" (Rev. 12:1–2). The woman faces another portent, a monstrous dragon intent on snatching her child as soon as it is born, a dragon so powerful that its tail

FRANCISCO DE ZURBARÁN
Immaculate Conception
MUSEO DEL PRADO
MADRID

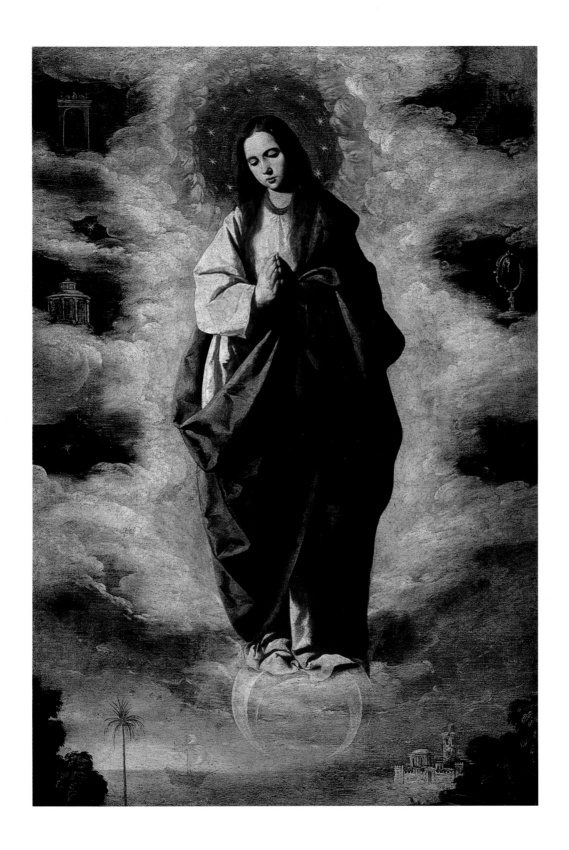

sweeps a third of the stars from the sky. Only with God's protection do the woman and child survive.

This passage always makes me reflect on the mixture of pain and joy and fear that any woman experiences in giving birth, the sense that dragons do indeed lie in wait. Will my child be healthy? Will I be able to raise it? Will the temptations of this world sweep it away, to an early spiritual or physical death? Why must I give birth to a creature who will one day die? As for myself, while I have never faced the vulnerability of giving birth, I have had to face the dragon in other ways. Adult life often seems to me a battle between the forces of life, which would have me admit how much I need to connect to other people, even to the point of being dependent on them, and the forces of death, which would have me disconnect from others in a vainglorious attempt to sustain the illusion of self-sufficiency.

My pleasure in the dogma of the bodily assumption of Mary into heaven has been greatly enhanced by the experience of hearing a monk who is a physics professor preach on this feast. In his homily he reminded us that while our bodies are indeed made of "star-stuff," modern cosmology has eliminated any direction called "upward." He went on to say that Mary's journey might not be seen as upward so much as inward, a life-long journey toward the kingdom of God within.

Before I had experienced the celebration of this dogma, I had thought it to be suspiciously escapist and otherworldly. I could not have been more wrong. The Assumption reminds us not to despise this world, even ordinary human flesh, because God has called it good, and found it worthy of heaven. It is a story about potentialities, specifically the human potential for goodness, and even holiness, that we so carelessly and consistently obscure. As for the dogma, it's in there somewhere, less

a matter of what I believe than who I am, someone who has very little difficulty with what Coleridge termed "the willing suspension of disbelief." It's in the singing and celebrating, and the homilies, in the stories about how beautiful, how generous and fruitful we are, or can be.

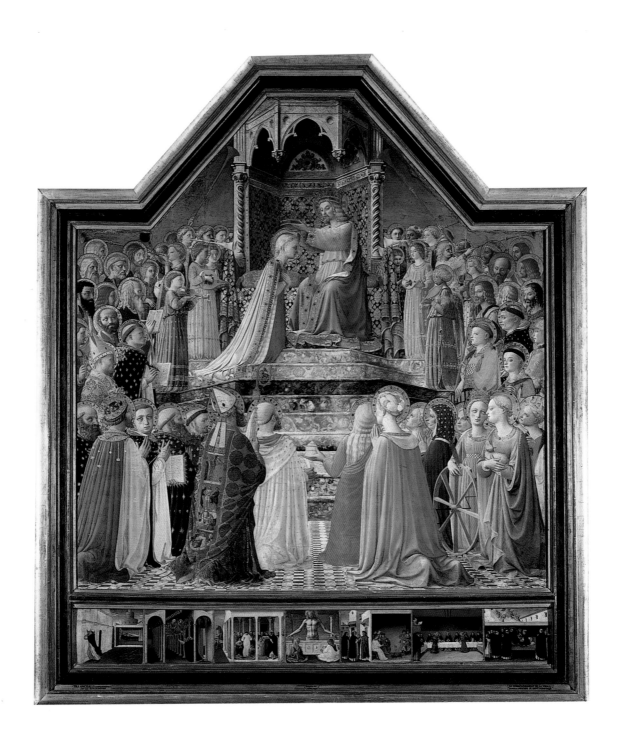

OZ

It is the eve of the Assumption. Neither virgin nor mother, I lie by the vigil light of the electric alarm clock and dream of walking to a city through a field of flowers, Dorothy on her way to the Emerald City. A crescent moon rides high in the East, and Orion lays down his sword.

A place to be: this womb of stars, this windy dawn. Fir trees begin to sift the light, their branches hung with gold. The pregnant cat sleeps in the shadow of the abbey church.

The building itself, with towers and turrets rising dramatically out of the Plains, has always reminded me of Oz. And the monks in their robes do have the air of the wizard about them; they remind me to "pay no attention to the man behind the curtain," but to focus on what lies beyond. The monastery has been a haven where I could come and stay a while, and work things out; the monks will not surrender Dorothy.

It was here that I first learned of the baptism of desire, and the gift of tears, the purifying tears that the ancient monks said could lead us to the love of God. Once, when a little girl in a small town nearby, staring at the bright red boots I often wore to work with children in schools, asked me, "Do you live

FRA ANGELICO
Coronation of the Virgin
MUSÉE DU LOUVRE, PARIS

in a country?" I told her we lived in the same country. She looked dubious. But as I thought about it, the real answer came—it's our secret country, where evil spells are broken by a promise of love, and little girls can melt away the wickedness that's in them.

LIFE
OF THE
VIRGIN

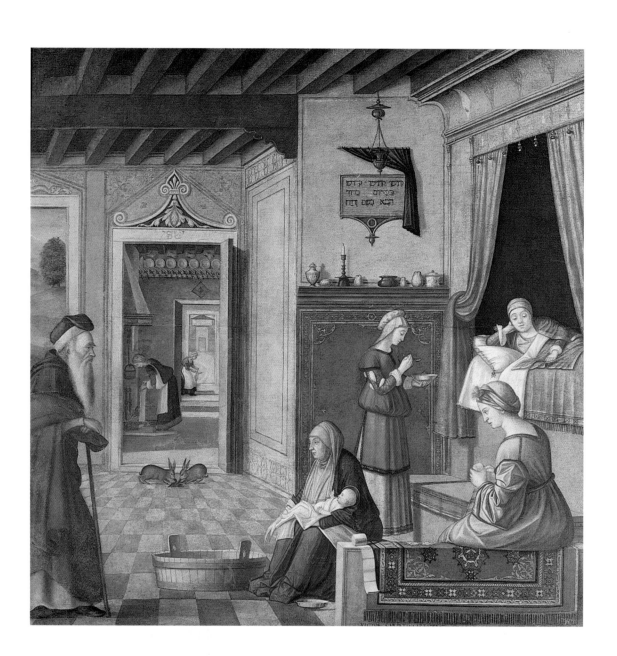

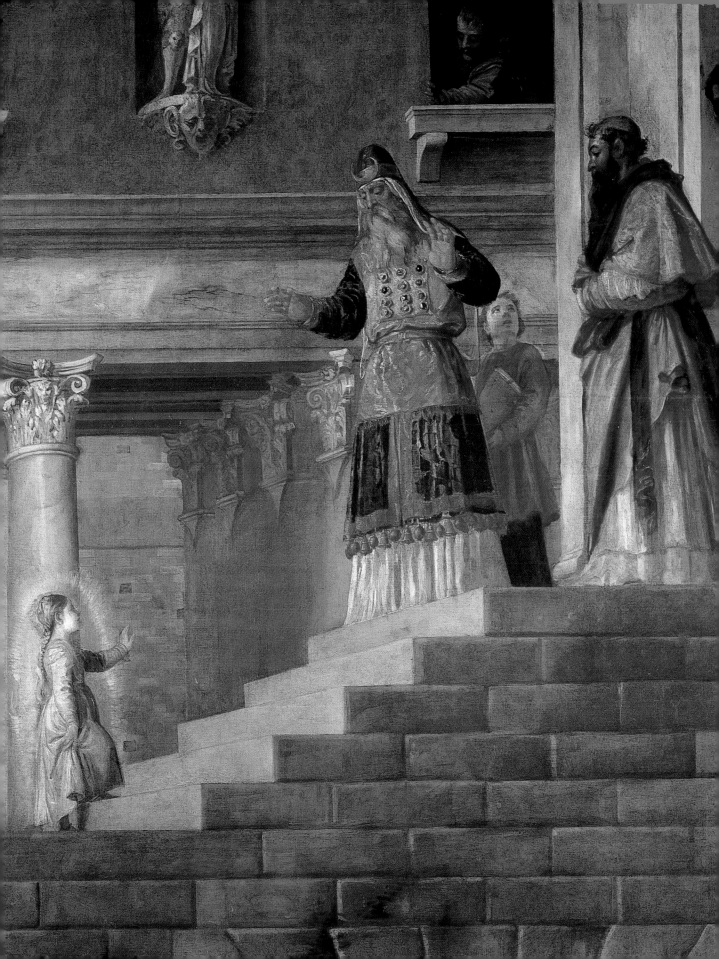

LUKE

CHAPTER 1

26 And in the sixth month the angel Gabriel was sent from God unto a city of Galilee, named Nazareth,

27 To a virgin espoused to a man whose name was Joseph, of the house of David; and the virgin's name *was* Mary.

28 And the angel came unto her, and said, Hail *thou that art* highly favoured, the Lord *is* with thee: blessed *art* thou among women.

29 And when she saw *him*, she was troubled at his saying, and cast in her mind what manner of salutation this should be.

30 And the angel said unto her, Fear not, Mary: for thou hast found favour with God.

31 And, behold, thou shalt conceive in thy womb, and bring forth a son, and shalt call his name JESUS.

32 He shall be great, and shall be called the Son of the Highest: and the Lord God shall give unto him the throne of his father David:

33 And he shall reign over the house of Jacob for ever; and of his kingdom there shall be no end.

34 Then said Mary unto the angel, How shall this be, seeing I know not a man?

35 And the angel answered and said unto her, The Holy Ghost shall come upon thee, and the power of the Highest shall overshadow thee: therefore also that holy thing which shall be born of thee shall be called the Son of God.

36 And, behold, thy cousin Elisabeth, she hath also conceived a
 son in her old age: and this is the sixth month with her, who
 was called barren.

37 For with God nothing shall be impossible.

38 And Mary said, Behold the handmaid of the Lord; be it unto
 me according to thy word. And the angel departed from her.

Page 54

Carpaccio
Birth of the Virgin
Accademia Carrara
Bergamo

Page 55

Titian
*Presentation of the
Virgin to the Temple*
detail
Galleria dell'
Accademia, Venice

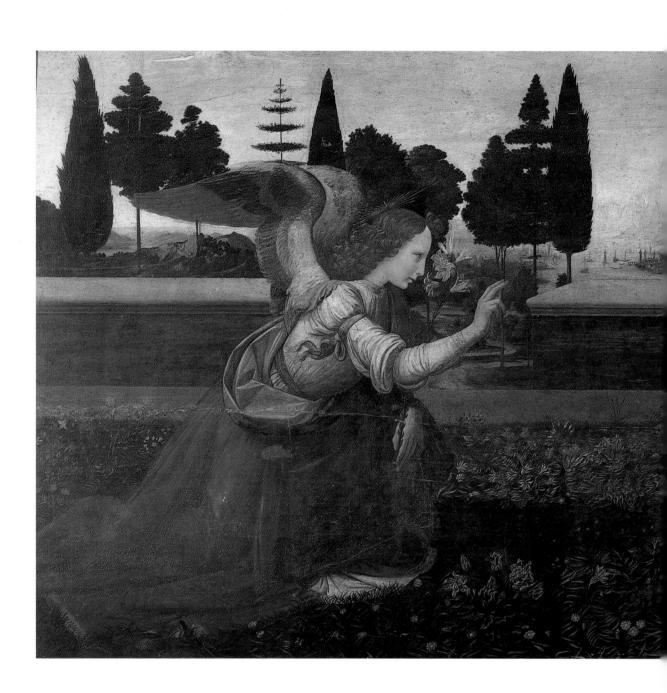

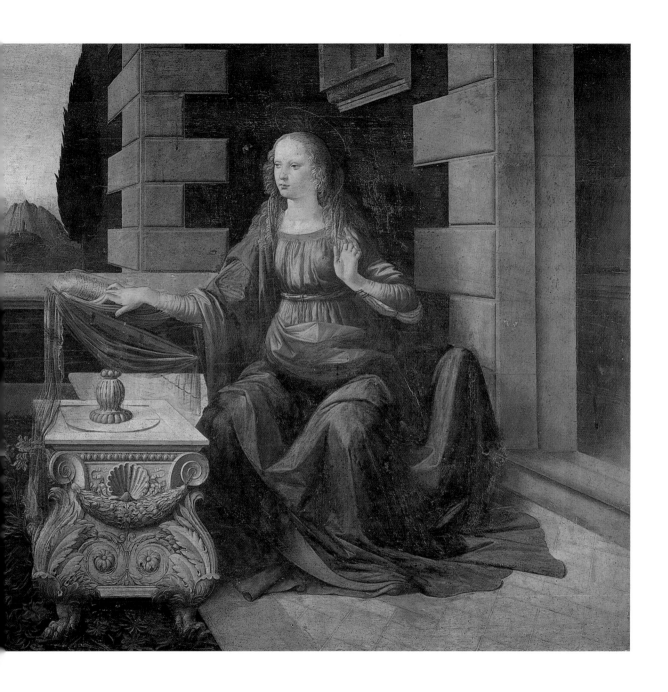

LUKE

CHAPTER 1

39 And Mary arose in those days, and went into the hill country with haste, into a city of Judah;

40 And entered into the house of Zacharias, and saluted Elisabeth.

41 And it came to pass, that, when Elisabeth heard the salutation of Mary, the babe leaped in her womb; and Elisabeth was filled with the Holy Ghost:

42 And she spake out with a loud voice, and said, Blessed *art* thou among women, and blessed *is* the fruit of thy womb.

43 And whence *is* this to me, that the mother of my Lord should come to me?

44 For, lo, as soon as the voice of thy salutation sounded in mine ears, the babe leaped in my womb for joy.

45 And blessed *is* she that believed: for there shall be a performance of those things which were told her from the Lord.

46 And Mary said, My soul doth magnify the Lord,

47 And my spirit hath rejoiced in God my Saviour.

48 For he hath regarded the low estate of his handmaiden: for, behold, from henceforth all generations shall call me blessed.

49 For he that is mighty hath done to me great things; and holy *is* his name.

50 And his mercy is on them that fear him from generation to generation.

51 He hath shown strength with his arm; he hath scattered the proud in the imagination of their hearts.

52 He hath put down the mighty from *their* seats, and exalted them of low degree.

RAPHAEL
*The Marriage
of the Virgin*
PINACOTECA DI BRERA
MILAN

53 He hath filled the hungry with good things; and the rich he hath sent empty away.

54 He hath helped his servant Israel, in remembrance of *his* mercy;

55 As he spake to our fathers, to Abraham, and to his seed for ever.

56 And Mary abode with her for three months, and returned to her own house.

JACOPO PONTORMO
The Visitation
SAN MICHELE
CARMIGNANO, ITALY

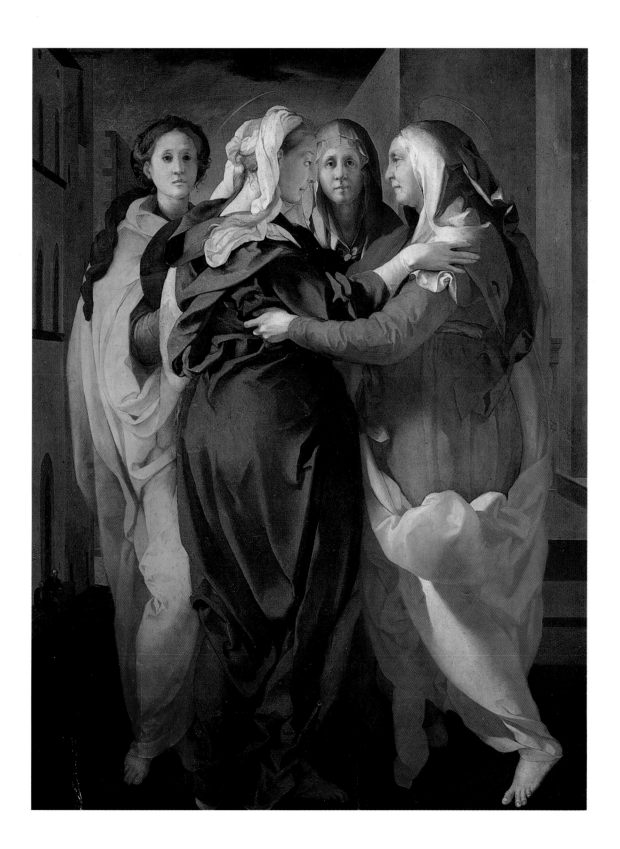

LUKE

CHAPTER 2

And it came to pass in those days, that there went out a decree from Caesar Augustus, that all the world should be taxed.

2 (*And* this taxing was first made when Cyrenius was governor of Syria.)

3 And all went to be taxed, every one into his own city.

4 And Joseph also went up from Galilee, out of the city of Nazareth, into Judaea, unto the city of David, which is called Bethlehem; (because he was of the house and lineage of David:)

5 To be taxed with Mary his espoused wife, being great with child.

6 And so it was, that, while they were there, the days were accomplished that she should be delivered.

7 And she brought forth her firstborn son, and wrapped him in swaddling clothes, and laid him in a manger; because there was no room for them in the inn.

GEORGES DE LA TOUR
The Nativity
MUSÉE DES BEAUX-ARTS
RENNES, FRANCE

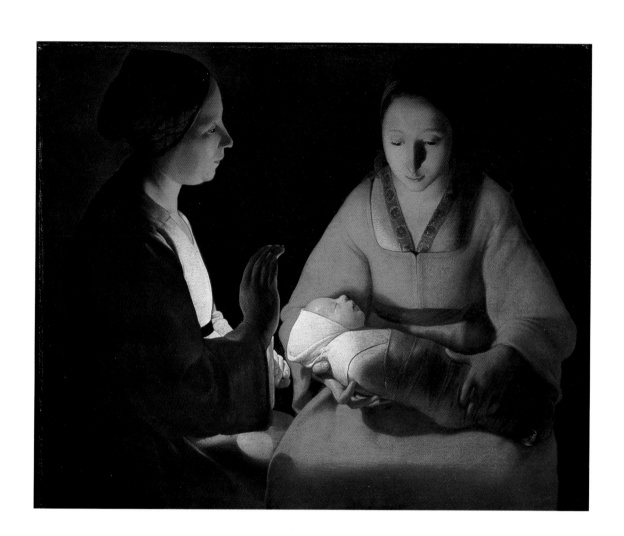

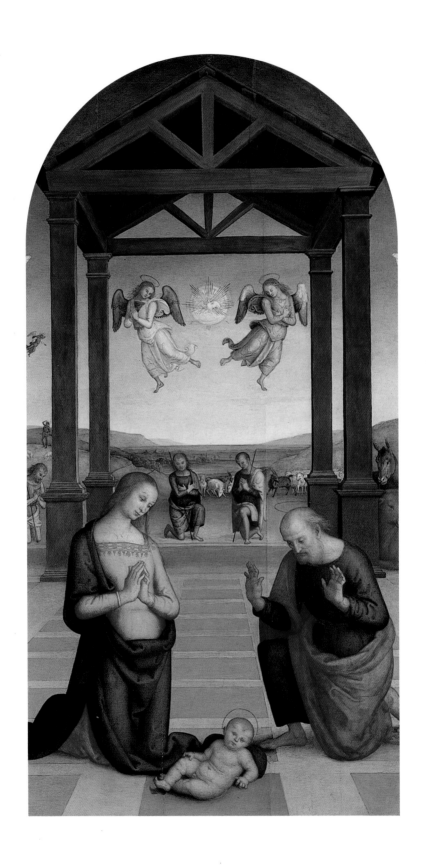

LUKE

CHAPTER 2

8 And there were in the country shepherds abiding in the field, keeping watch over their flock by night.

9 And, lo, the angel of the Lord came upon them, and the glory of the Lord shone round about them: and they were sore afraid.

10 And the angel said unto them, Fear not: for, behold, I bring you good tidings of great joy, which shall be to all people.

11 For unto you is born this day in the city of David a Saviour, which is Christ the Lord.

12 And this *shall be* a sign unto you; Ye shall find the babe wrapped in swaddling clothes, lying in a manger.

13 And suddenly there was with the angel a multitude of the heavenly host praising God, and saying,

14 Glory to God in the highest, and on earth peace, good will toward men.

15 And it came to pass, as the angels were gone away from them into heaven, the shepherds said one to another, Let us now go even unto Bethlehem, and see this thing which is come to pass, which the Lord hath made known to us.

16 And they came with haste, and found Mary, and Joseph, and the babe lying in a manger.

17 And when they had seen *it*, they made known abroad the saying which was told them concerning this child.

18 And all they that heard *it* wondered at those things which were told them by the shepherds.

19 But Mary kept all these things, and pondered *them* in her heart.

PIETRO PERUGINO
The Nativity
GALLERIA NAZIONALE
DELL' UMBRIA, PERUGIA

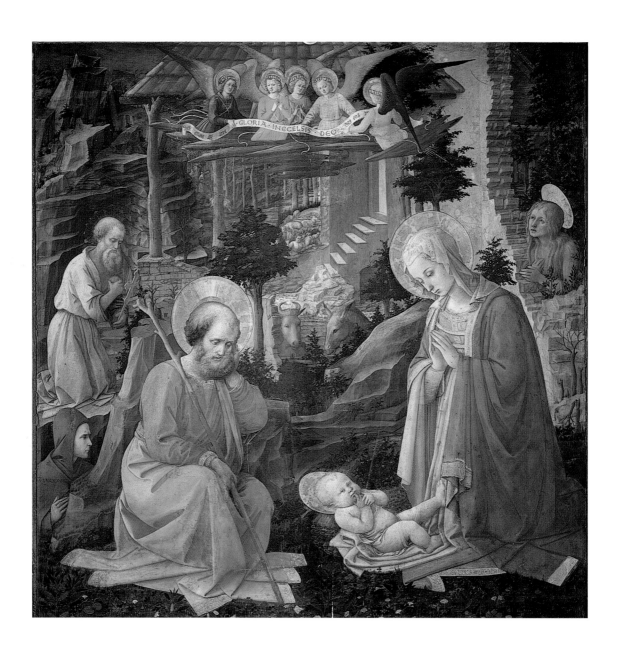

20 And the shepherds returned, glorifying and praising God for all the things that they had heard and seen, as it was told unto them.

Fra Filippo Lippi
Adoration of the Child
Galleria degli Uffizi
Florence

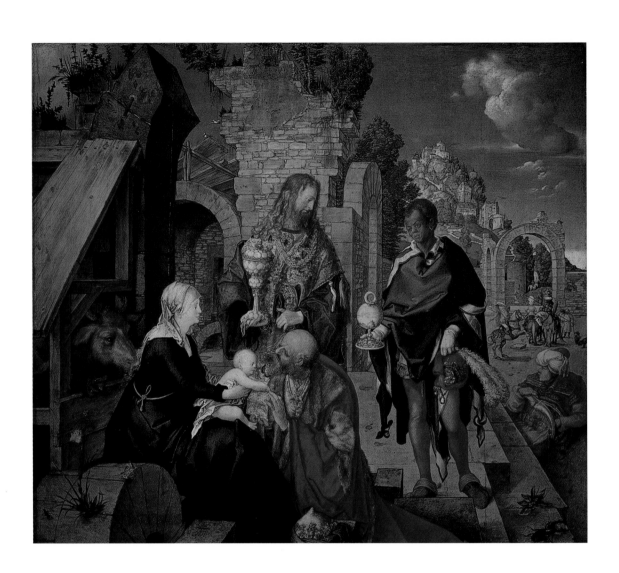

MATTHEW

CHAPTER 2

Now when Jesus was born in Bethlehem of Judaea in the days of Herod the king, behold, there came wise men from the east to Jerusalem,

2 Saying, Where is he that is born King of the Jews? for we have seen his star in the east, and are come to worship him.

3 When Herod the king had heard *these things*, he was troubled, and all Jerusalem with him.

4 And when he had gathered all the chief priests and scribes of the people together, he demanded of them where Christ should be born.

5 And they said unto him, In Bethlehem of Judaea: for thus it is written by the prophet,

6 And thou Bethlehem, *in* the land of Judah, art not the least among the princes of Judah: for out of thee shall come a Governor, that shall rule my people Israel.

7 Then Herod, when he had privily called the wise men, inquired of them diligently what time the star appeared.

8 And he sent them to Bethlehem, and said, Go and search diligently for the young child; and when ye have found *him*, bring me word again, that I may come and worship him also.

9 When they had heard the king, they departed; and, lo, the star, which they saw in the east, went before them, till it came and stood over where the young child was.

10 When they saw the star, they rejoiced with exceeding great joy.

11 And when they were come into the house, they saw the young child with Mary his mother, and fell down, and worshipped

Albrecht Dürer
Adoration of the Magi
Galleria degli Uffizi
Florence

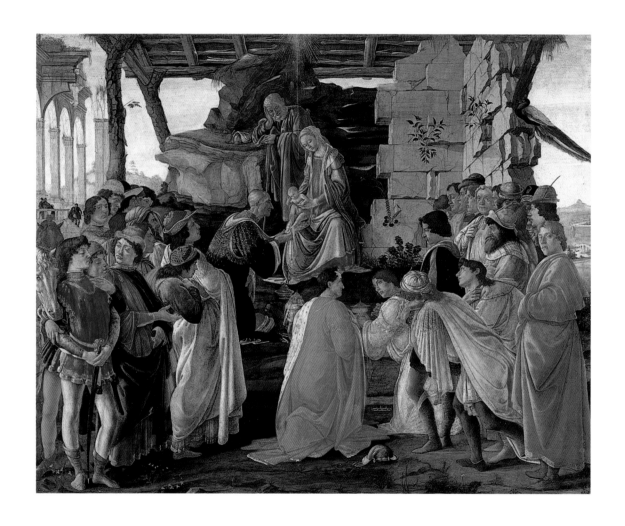

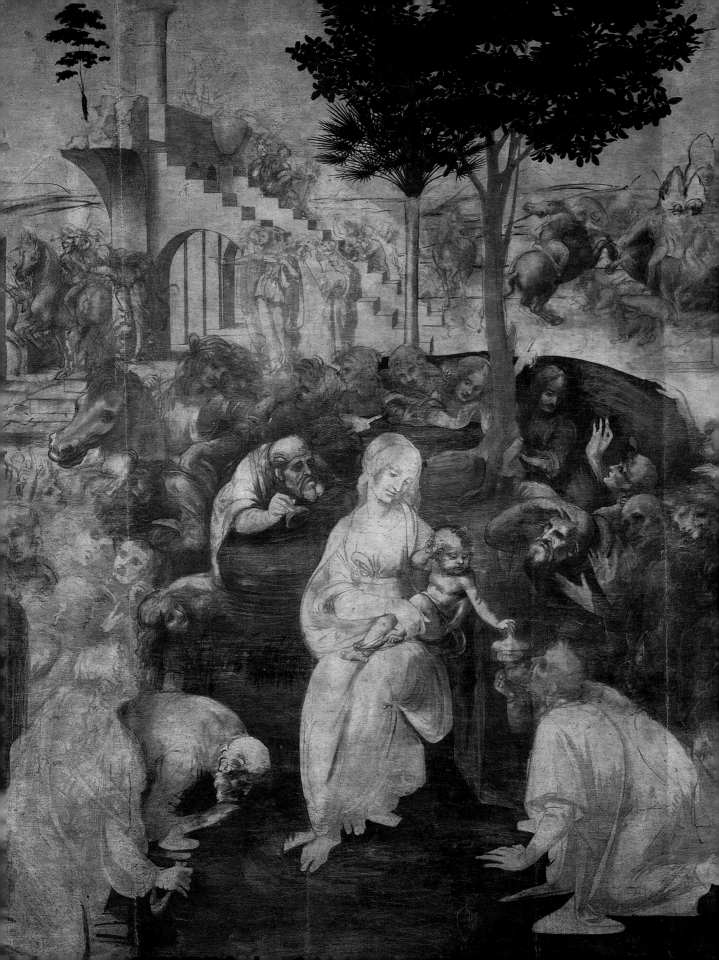

him: and when they had opened their treasures, they presented unto him gifts; gold, frankincense, and myrrh.

12 And being warned of God in a dream that they should not return to Herod, they departed into their own country another way.

REMBRANDT
HARMENSZ VAN RIJN
Flight into Egypt
MUSÉE DES BEAUX-ARTS
TOURS

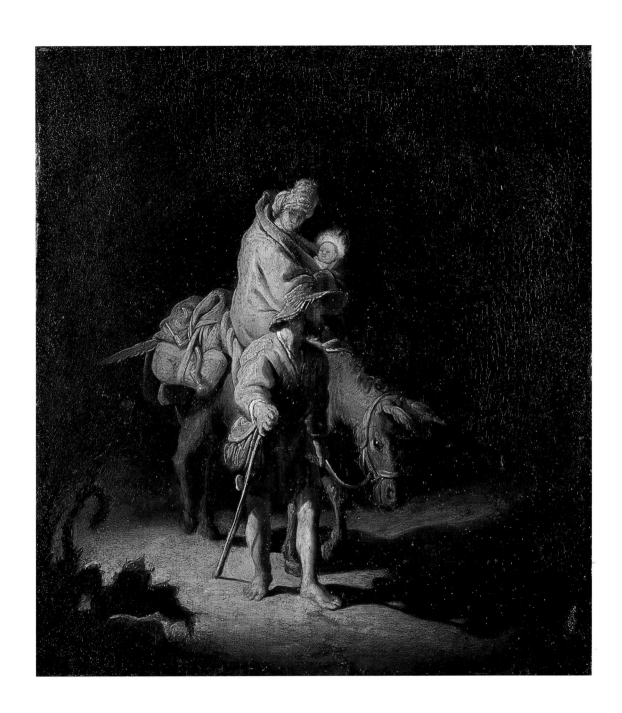

MATTHEW

CHAPTER 2

13 And when they were departed, behold, the angel of the Lord appeareth to Joseph in a dream, saying, Arise, and take the young child and his mother, and flee into Egypt, and be thou there until I bring thee word: for Herod will seek the young child to destroy him.

14 When he arose, he took the young child and his mother by night, and departed into Egypt:

15 And was there until the death of Herod: that it might be fulfilled which was spoken of the Lord by the prophet, saying, Out of Egypt have I called my son.

CORREGGIO
*Rest on the Flight
into Egypt*
GALLERIA DEGLI UFFIZI
FLORENCE

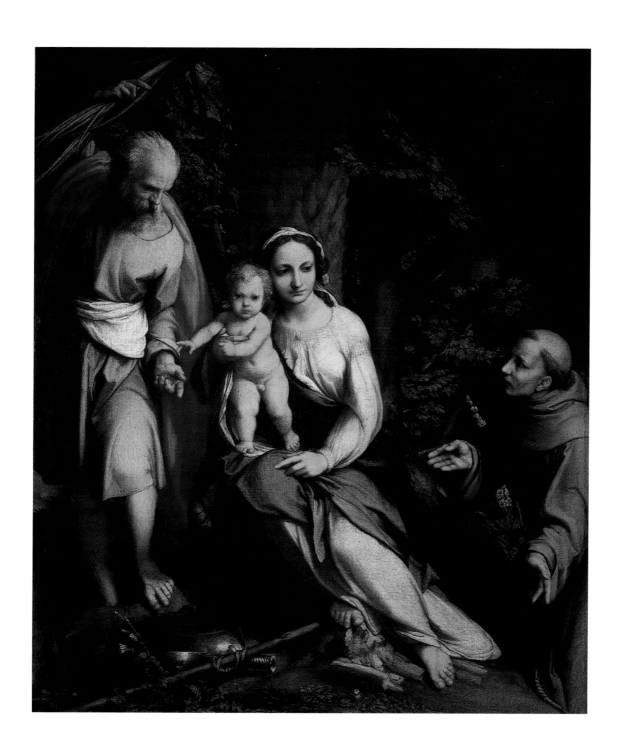

LUKE

CHAPTER 2

21 And when eight days were accomplished for the circumcising of the child, his name was called JESUS, which was so named of the angel before he was conceived in the womb.

22 And when the days of her purification according to the law of Moses were accomplished, they brought him to Jerusalem, to present *him* to the Lord;

23 (As it was written in the law of the Lord, Every male that openeth the womb shall be called holy to the Lord;)

24 And to offer a sacrifice according to that which is said in the law of the Lord, A pair of turtledoves, or two young pigeons.

25 And, behold, there was a man in Jerusalem, whose name *was* Simeon; and the same man *was* just and devout, waiting for the consolation of Israel: and the Holy Ghost was upon him.

26 And it was revealed unto him by the Holy Ghost, that he should not see death, before he had seen the Lord's Christ.

27 And he came by the Spirit into the temple: and when the parents brought in the child Jesus, to do for him after the custom of the law,

28 Then took he him up in his arms, and blessed God, and said,

29 Lord, now lettest thou thy servant depart in peace, according to thy word:

30 For mine eyes have seen thy salvation,

31 Which thou hast prepared before the face of all people;

32 A light to lighten the Gentiles, and the glory of thy people Israel.

78

ANDREA MANTEGNA
The Circumcision, DETAIL
GALLERIA DEGLI UFFIZI
FLORENCE

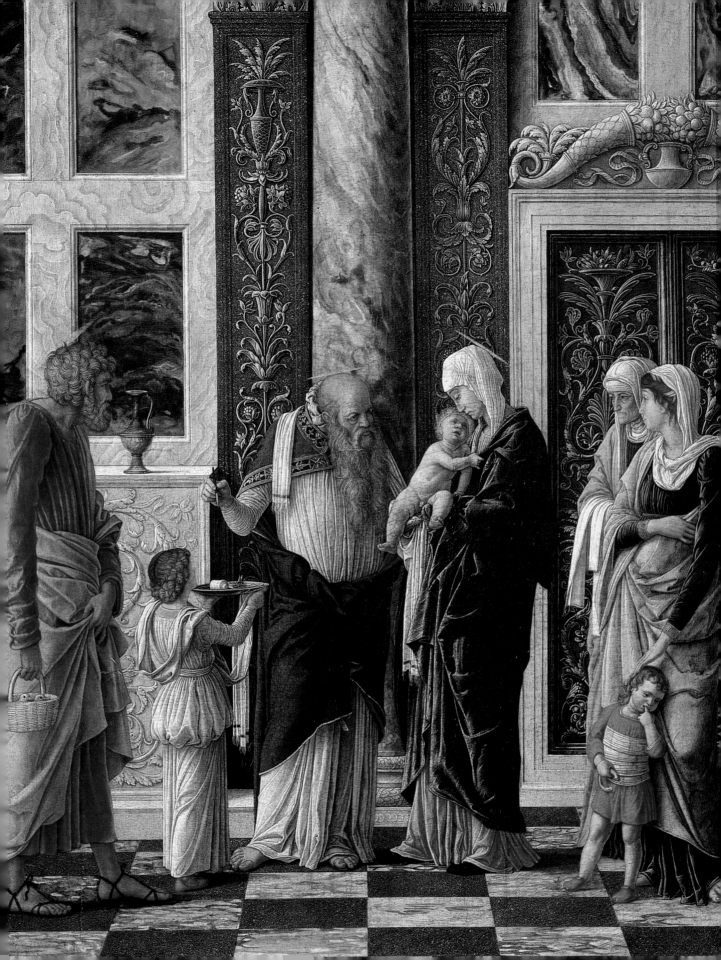

33 And Joseph and his mother marvelled at those things which were spoken of him.

34 And Simeon blessed them, and said unto Mary his mother, Behold, this *child* is set for the fall and rising again of many in Israel; and for a sign which shall be spoken against;

35 (Yea, a sword shall pierce through thy own soul also,) that the thoughts of many hearts may be revealed.

36 And there was one Anna, a prophetess, the daughter of Phanuel, of the tribe of Aser: she was of a great age, and had lived with an husband seven years from her virginity;

37 And she *was* a widow of about fourscore and four years, which departed not from the temple, but served *God* with fastings and prayers night and day.

38 And she coming in that instant gave thanks likewise unto the Lord, and spake of him to all them that looked for redemption in Jerusalem.

39 And when they had performed all things according to the law of the Lord, they returned into Galilee, to their own city Nazareth.

40 And the child grew, and waxed strong in spirit, filled with wisdom: and the grace of God was upon him.

JEAN JOUVENET
*The Presentation of
Christ in the Temple*
MUSÉE DES BEAUX-ARTS
ROUEN

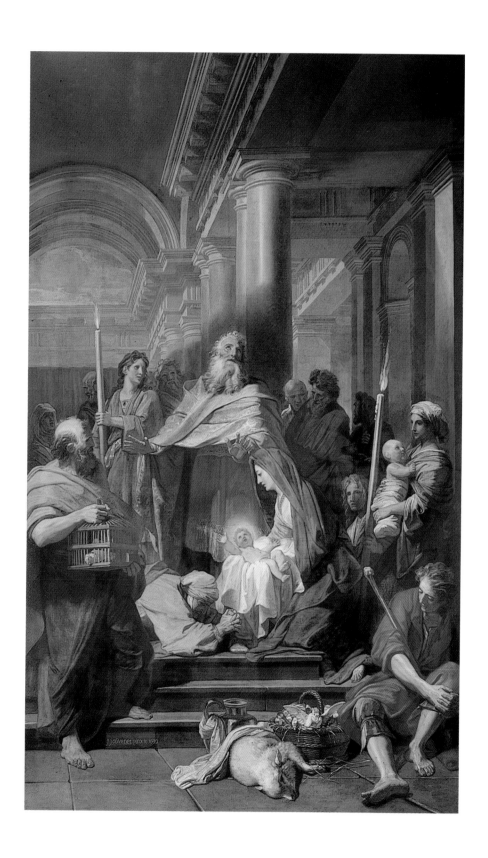

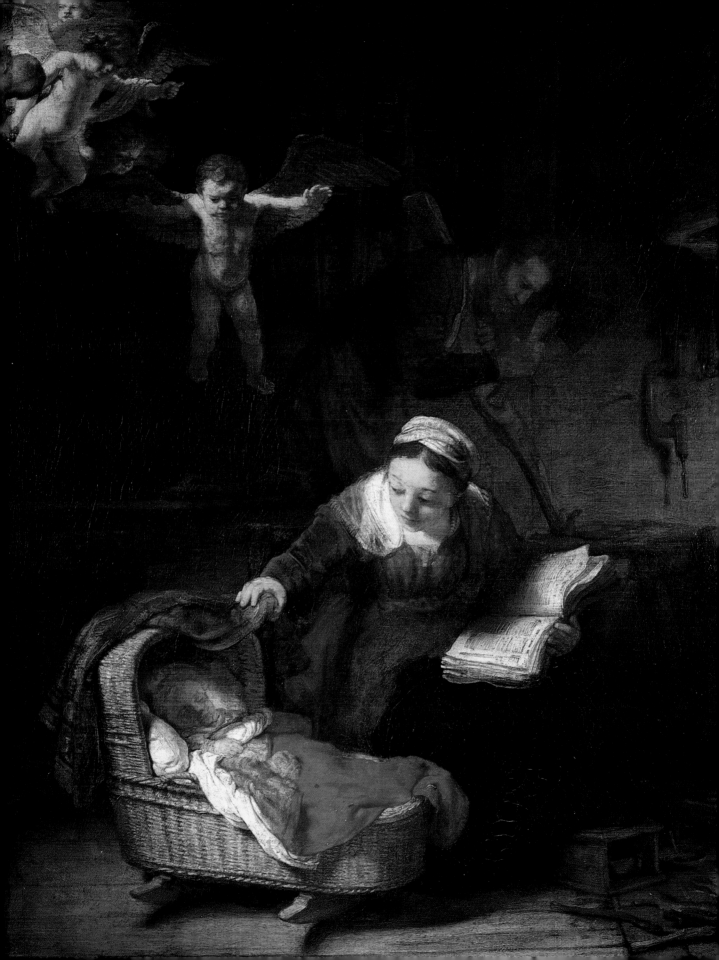

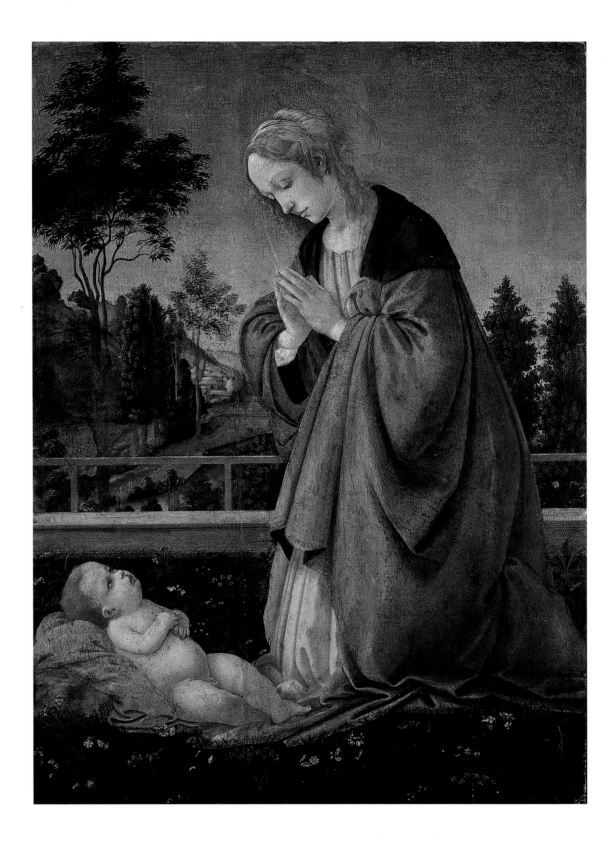

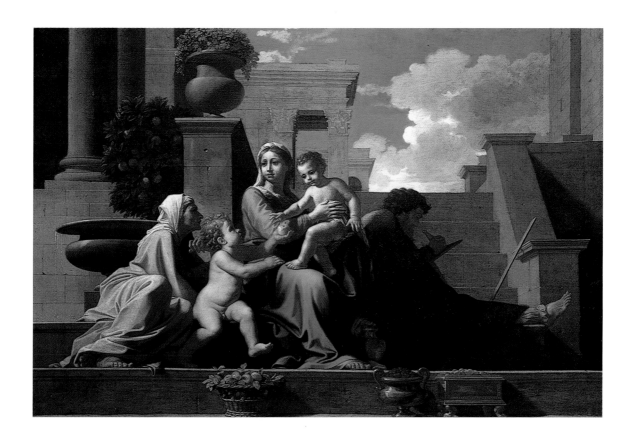

Opposite
FILIPPINO LIPPI
Adoration of the Child
GALLERIA DEGLI UFFIZI
FLORENCE

NICOLAS POUSSIN
*The Holy Family on
the Stairs*
CLEVELAND MUSEUM
OF ART

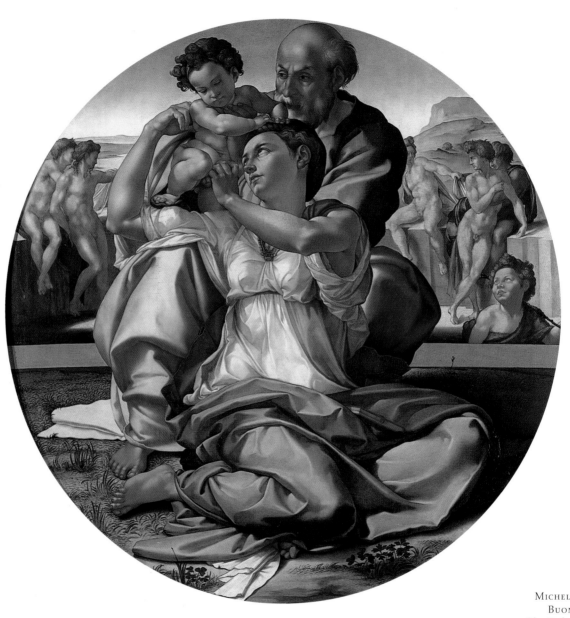

MICHELANGELO
BUONARROTI
The Holy Family
GALLERIA DEGLI UFFIZI
FLORENCE

Opposite
AGNOLO BRONZINO
*The Holy Family
with Saint Anna and
John the Baptist*
MUSÉE DU LOUVRE
PARIS

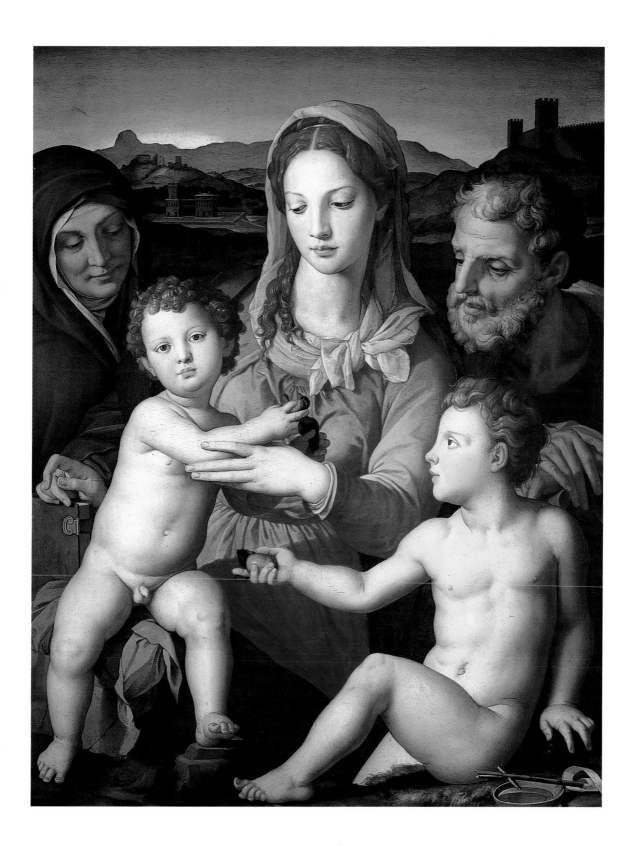

LUKE

CHAPTER 2

41 Now his parents went to Jerusalem every year at the feast of the passover.

42 And when he was twelve years old, they went up to Jerusalem after the custom of the feast.

43 And when they had fulfilled the days, as they returned, the child Jesus tarried behind in Jerusalem; and Joseph and his mother knew not *of it*.

44 But they, supposing him to have been in the company, went a day's journey; and they sought him among *their* kinsfolk and acquaintance.

45 And when they found him not, they turned back again to Jerusalem, seeking him.

46 And it came to pass, that after three days they found him in the temple, sitting in the midst of the doctors, both hearing them, and asking them questions.

47 And all that heard him were astonished at his understanding and answers.

48 And when they saw him, they were amazed: and his mother said unto him, Son, why hast thou thus dealt with us? behold, thy father and I have sought thee sorrowing.

49 And he said unto them, How is it that ye sought me? wist ye not that I must be about my Father's business?

50 And they understood not the saying which he spake unto them.

51 And he went down with them, and came to Nazareth, and was subject unto them: but his mother kept all these sayings in her heart.

88

BERNARD VAN ORLEY
*Christ among
the Doctors*
NATIONAL
GALLERY OF ART
WASHINGTON, D.C.

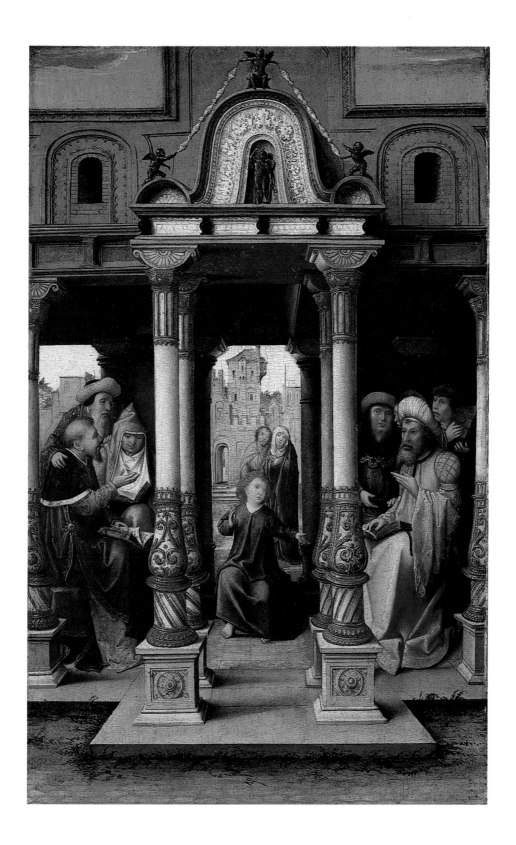

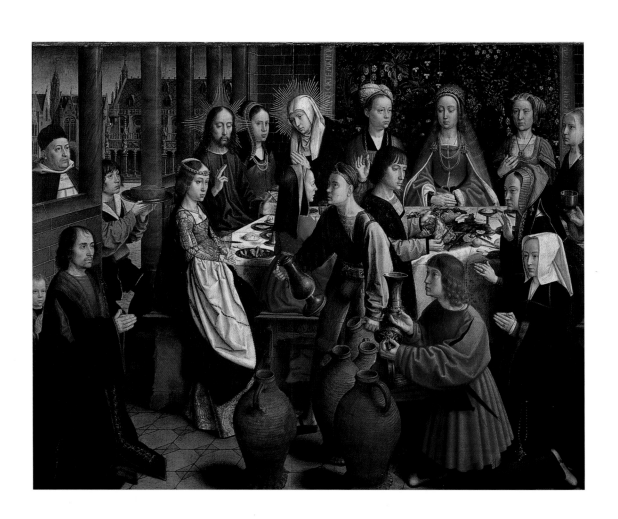

JOHN

CHAPTER 2

And the third day there was a marriage in Cana of Galilee; and the mother of Jesus was there:

2 And both Jesus was called, and his disciples, to the marriage.

3 And when they wanted wine, the mother of Jesus saith unto him, They have no wine.

4 Jesus saith unto her, Woman, what have I to do with thee? mine hour is not yet come.

5 His mother saith unto the servants, Whatsoever he saith unto you, do *it*.

6 And there were set there six waterpots of stone, after the manner of the purifying of the Jews, containing two or three firkins apiece.

7 Jesus saith unto them, Fill the waterpots with water. And they filled them to the brim.

8 And he saith unto them, Draw out now, and bear unto the governor of the feast. And they bare *it*.

9 When the ruler of the feast had tasted the water that was made wine, and knew not whence it was, (but the servants which drew the water knew,) the governor of the feast called the bridegroom,

10 And saith unto him, Every man at the beginning doth set forth good wine; and when men have well drunk, then that which is worse: *but* thou hast kept the good wine until now.

11 This beginning of miracles did Jesus in Cana of Galilee, and manifested forth his glory; and his disciples believed on him.

HANS MEMLING
The Seven Joys of Mary
ALTE PINAKOTHEK
MUNICH

JOHN

CHAPTER 19

25 Now there stood by the cross of Jesus his mother, and his mother's sister, Mary the *wife* of Cleophas, and Mary Magdalene.

26 When Jesus therefore saw his mother, and the disciple standing by, whom he loved, he saith unto his mother, Woman, behold thy son!

27 Then saith he to the disciple, Behold thy mother! And from that hour that disciple took her unto his own home.

PIETRO PERUGINO
*The Deposition
from the Cross*
ACCADEMIA, FLORENCE

Following pages

JACOPO PONTORMO
The Deposition
CAPELLA CAPPONI
SANTA FELICITÀ
FLORENCE

MICHELANGELO MERISI
DA CARAVAGGIO
The Deposition
VATICAN MUSEUM, ROME

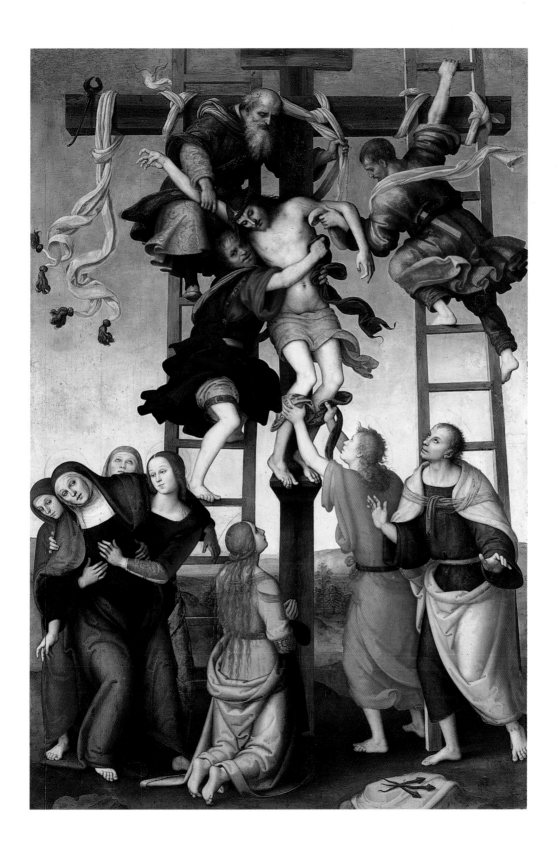

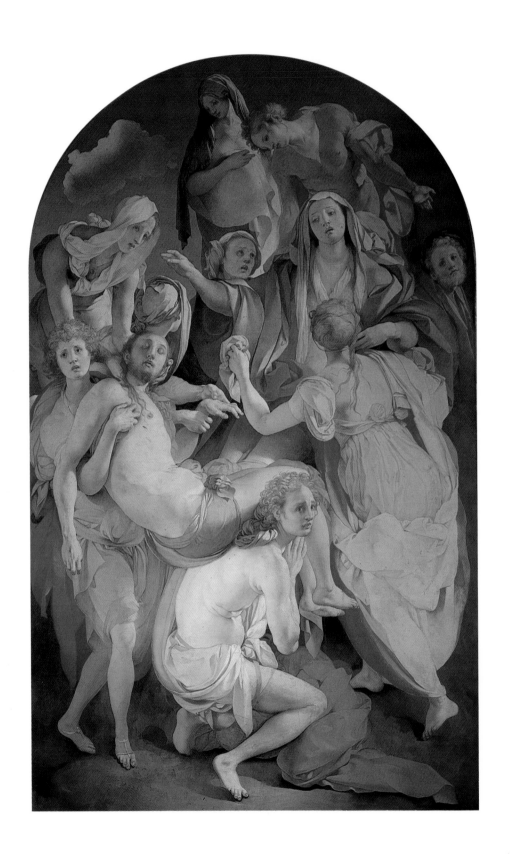

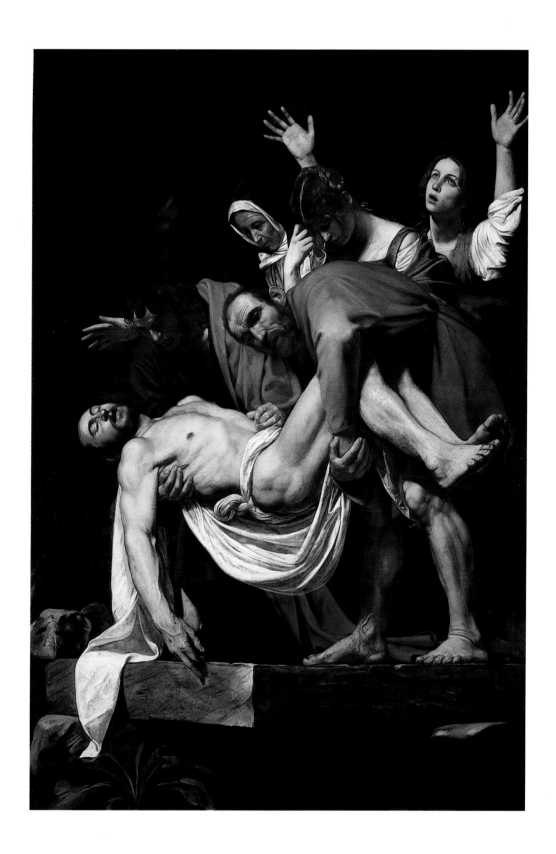

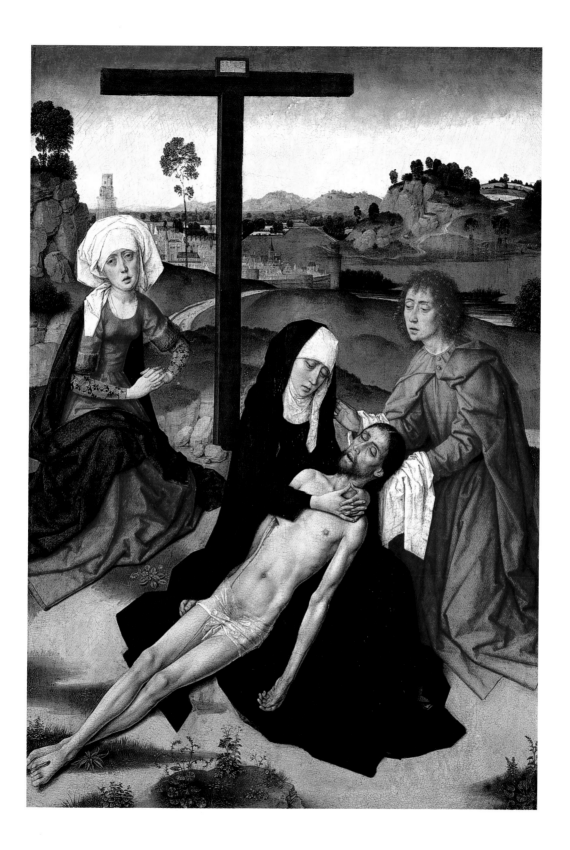

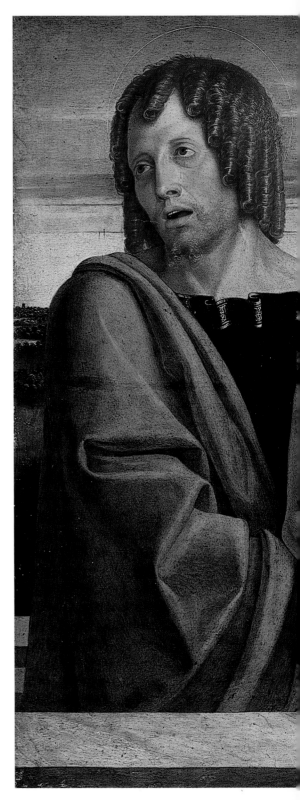

GIOVANNI BELLINI
Pietà
PINACOTECA DI BRERA
MILAN

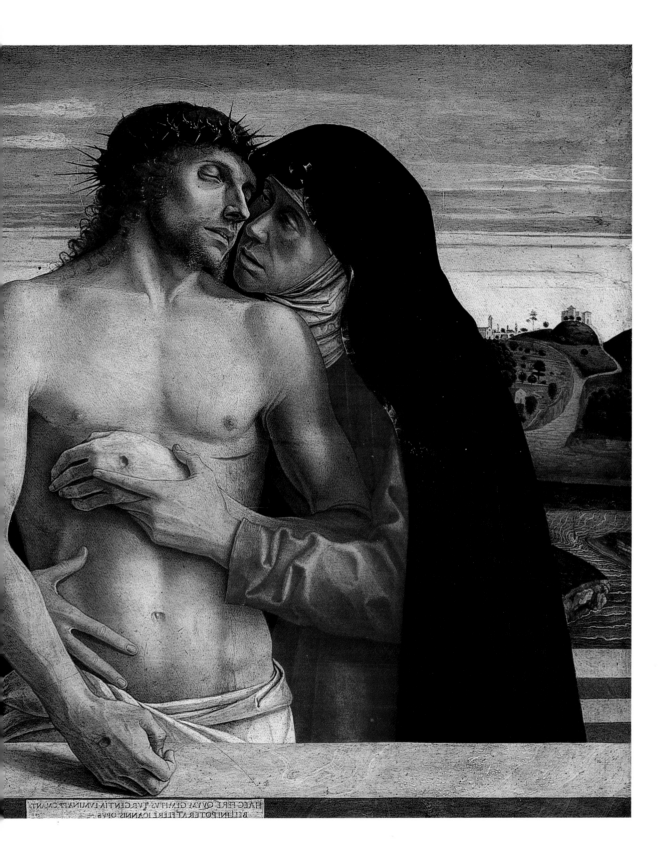

HAEC FERE QVVM GEMITVS TVRGENTIA LVMINA PROMANT
BELLINI POTERAT FLERE IOANNIS OPVS

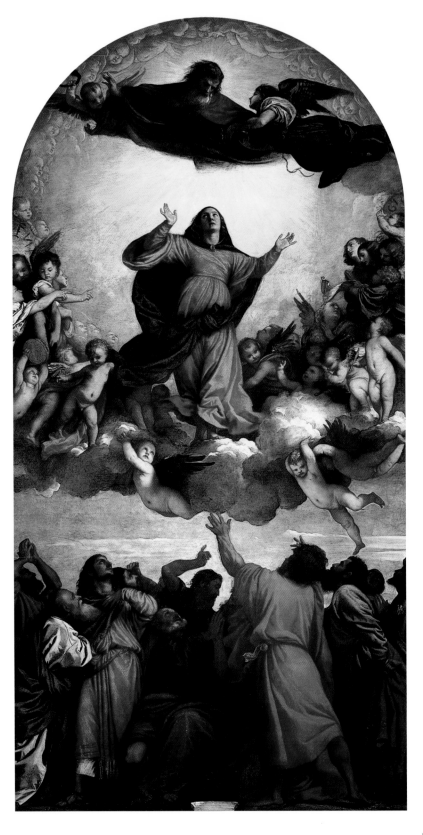

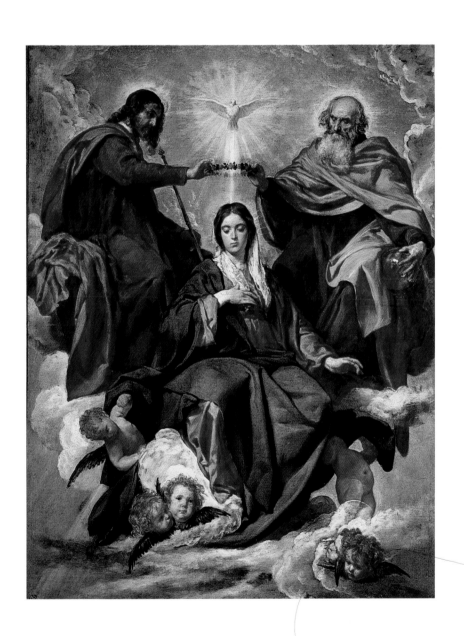

VELÁZQUEZ
*Coronation of
the Virgin*
MUSEO DEL PRADO
MADRID

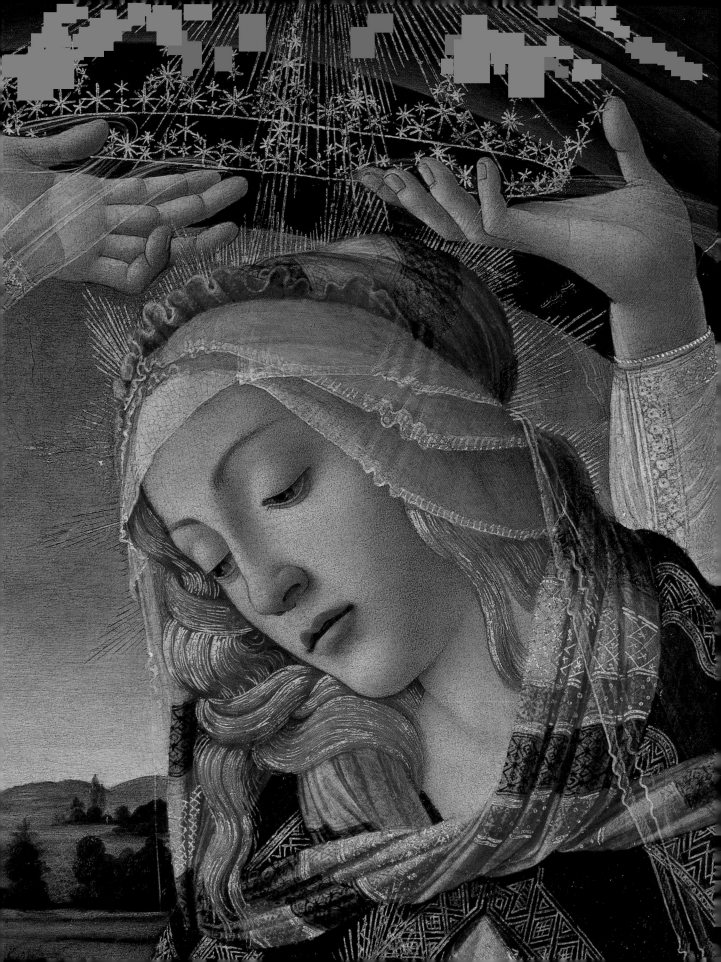

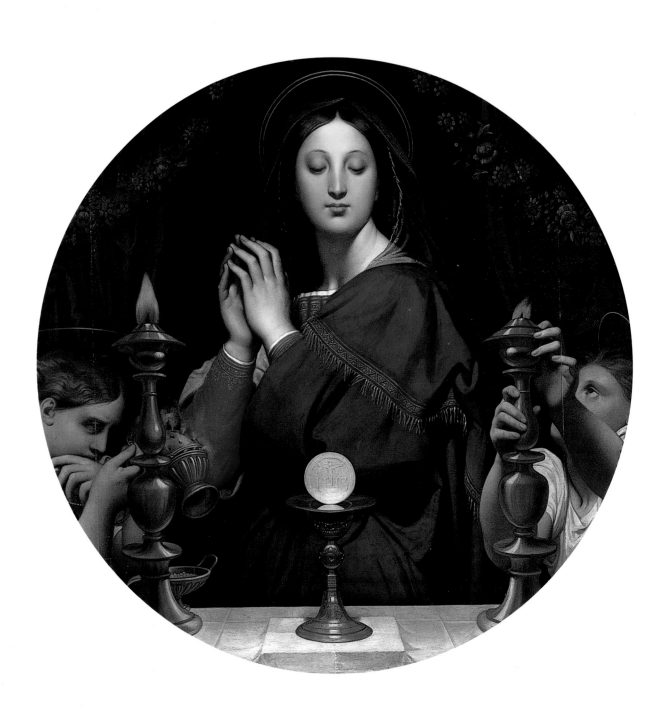

INDEX OF ARTISTS

Angelico, Fra (*ca.* 1400–1455), 26, 50

Bellini, Giovanni (*ca.* 1430–1516), 101, 108

Botticelli, Sandro (1445–1510), 6, 12, 72, 107

Bouts, Dirck (*ca.* 1420–1475), 99

Bronzino, Agnolo (1503–1572), 87

Caravaggio, Michelangelo Merisi da (1573–1610), 97, 103

Carpaccio, Vittore (*ca.* 1460–1525 or 1526), 54

Correggio, Antonio Allegri da (1494–1534), 76

David, Gerard (*ca.* 1460–1523), 90

Dürer, Albrecht (1471–1528), 70

Eyck, Jan van (1395–1441), 4

Fresquis, Pedro Antonio (*ca.* 1780-1830), 24

Greco, El (Doménikos Theotokópoulos, 1541–1614), 32

Ingres, Jean Auguste Dominique (1780–1867), 110

Jouvenet, Jean (1644–1717), 81

La Tour, Georges de (1593–1652), 10, 65

Leonardo da Vinci (1452–1519), 3, 58–59, 73

Lippi, Filippino (*ca.* 1457–1504), 84

Lippi, Fra Filippo (*ca.* 1406–1469), 68

Mantegna, Andrea (1431–1506), 2, 78

Martini, Simone (*ca.* 1284–1344), 36

Memling, Hans (*ca.* 1430–1494), 5, 92–93

Michelangelo di Lodovico Buonarroti Simoni (1475–1564), 20, 86

Orley, Bernard van (*ca.* 1488–1541), 89

Perugino, Pietro (*ca.* 1450–1523), 66, 95

Piero della Francesca (1420–1492), 19

Pontormo, Jacopo da (1494–1557), 62, 96

Poussin, Nicolas (1594–1665), 42, 85

Raphael (1483–1520), 1, 45, 60

Rembrandt Harmensz van Rijn (1606–1669), 75, 83

Rossetti, Dante Gabriel (1828–1882), 29

Rubens, Peter Paul (1577–1640), 9

Titian (*ca.* 1488–1576), 55, 104

Velázquez, Diego Rodríguez de Silva (1599–1660), 105

Zurbarán, Francisco de (1598–1664), 47

JEAN AUGUSTE
DOMINIQUE INGRES
Madonna with the Host
MUSÉE D'ORSAY
PARIS

PHOTO CREDITS